Little Men

For Dennis Cooper, who thought of it
and
Dodie Bellamy, who thought of the rest

LITTLE MEN

KEVIN KILLIAN

lingo books

HARD PRESS, INC. 1996

Acknowledgements

"Little Men" was written for Brett Reichman's show of the same name at Micher/Wilcox Gallery (San Francisco) and later published in "Mirage #4/Period[ical]." "Santa" appeared as a chapbook from Leave Books (Buffalo) in 1995. "Zoo Story" first appeared in *A Taste of Latex #7* (San Francisco), 1992. I wrote "Chain of Fools" for Brian Bouldrey's 1995 anthology *Wrestling the Angel: Faith and Religion in the Lives of Gay Men* (Riverhead Books). "Spread Eagle" appeared in the magazine *Front* (Vancouver) in 1991 and in Dennis Cooper's anthology *Discontents: New Queer Writers* (New York: Amethyst Press), 1992. Stephen Beachy and I wrote "Corpse" as an exquisite corpse experiment; it appeared in "Some Weird Sin II" in 1994. I wrote "Brother and Sister," and Brett Reichman made drawings for it, and Jonathan Hammer made an artist's book from it, for his show at Matthew Marks Gallery, New York, 1994. "Who is Kevin Killian?" appeared in *Avec #7*, ed. Norma Cole. I wrote "Philosophy" to accompany Nayland Blake's Sade show at San Francisco Artspace, 1993. My thanks to all these editors, artists, curators and writers and especially to John Yau, Michael Gizzi and Jon Gams of Hard Press.

A Hard Press/*lingo* Series Book
Copywrite © 1996
P.O. Box 184
West Stockbridge, MA 01266

Library of Congress Cataloging

Killian, Kevin
 Little men/Kevin Lillian

 ISBN 1-889097-01-2 (alk. paper)

CONTENTS

Little Men	10
Santa	13
Father and Son (with Josh Cherin)	32
Zoo Story	43
Chain of Fools	47
Spread Eagle	57
Corpse (with Stephen Beachy)	62
A Love Like That	65
Brother and Sister	74
Philosophy	84
Who Is Kevin Killian?	94

Little Men

Grandly I stepped down a long, red hall filled with mirrors and tinflowers, into a space I knew was hell. In "Fairyland" I saw two of my best friends, little people—one still eager, the other aloof and scared. They perched on the bones of an elk, a long curve of bone they took for some amusement ride. "No," I said, "you are riding on death." "Oh shit," said my one little elf. "But still—even though our lives pass in the realms of hell, we try to have some fun."

I had no answer to this. In three mirrors I saw my face, me, Pinocchio—first a little snub nose, then a fullsize regulation *rod*; then this big misshapen root I could hurt you with—if I didn't like you—so watch it! I used to look at myself in a mirror hoping something would change. At the mirror's edge my vision fractured into realms of spray—a token of my own love of myself, a gesture toward Walt Whitman. "Who's the fairest," I demanded, with full confidence the reply would be "You, Kevin." In this case the reply appears as an image—my own image, big dick and all. Well fuck that.

I'm like this little fairy in a big hellish world I never dreamed of. There are these two foxy guys in Robin Hood jerkins. According to them I've got a few days to live. Don't want them to think bad about me! Layers of vertical stripes of paint top us, and the light here is spooky, maybe—but you know how it is. We've been damaged, but Aesop or Malory or Grimm or Perreault is still writing about us. Fable's got the strength of a rumor; or a virus, *mais non*?

I guess.

When I was a kid I thought there was poetry inside the frame, a cage, a capture, a bar set. I'm mooning over him, I'm a wax fig-

urine. He's so flexed and haughty—he makes my jaw weak. I'm in this club, and what we do, is, we go to bars and try to pick up guys? It's funny when they come home with us and we can't even understand each other except you know, the universal language of love.

Then when I came to S.F. the gates clanged shut, once, twice, three times. This archetypal number that was—that was AIDS. Remember in *Bambi* when Bambi's mother died in the fire? Well, that was nothing. Here are these big old fawns, hooves of cast-iron, trotting above me in this forest glade; but as I look closer the blue butterfly's a stick of carved wood, Ladybug's red shell's brittle like Faberge, spotted and dotted. I'm about to get hoofed right in the midsection or balls if I had any.

—We were not really boys or anywhere near it; but crafted animulcae, fetiches from world culture. Our old-time outfits came not from The Gap but from the imagination of 19th century illustrators, Disney animators, all that is false we were dressed in and smiled through. I can't even remember did we ever have sex or if so with what as I haven't seen myself naked. A smell of resin and pinewood comes out of my body as it would from an empty coffin. We're adorable, sure.

I went up to Brett Reichman in his painter's studio, a colorful place like my workshop at the North Pole. His pale face, his bangs, his glasses. He acted a bit defensive, but not overly so considering he had put me in Hell, into this hell of not-belonging or being. "Cut me some slack," I pleaded, "don't be such a *mensch*, night and day, you are the one."

Impassive he looked at me as if to say, *suffer*. Tonight, some of us elves and imps and pixies—we held a demo outside the studio but failed to attract KGO and the other networks, I don't know, maybe we should have used bullhorns instead of faery pipes.

"We never belonged to ourselves, but now we are his," we chanted in these fey high-pitched voices, all in unison, practically, except for Squeeker—the lamb whose wool was replaced by plastic, white and pink, long ago, before we came to this red room and met *all these incredible guys*! "Now we are his," we repeated over

and over, raising our fists into the night air beyond which beckoned the branches of these cruel, half-human trees that wanted to eat us? Well, eat this.

for Brett Reichman

Santa

I'll be writing two stories at the same time, but think of this as no "New Narrative" trick but as a kind of Victorian novel in miniature. Three stories really, because I've stretched out Brad Gooch's "Satan," as one might stretch a canvas before hitting the palette. In "Satan," a photographer, Eddie, so badly abuses his black model that even his rich white patrons, who like abuse to a certain point, start to drop him. This causes him to see the light and to change his ways. Reading the story you can't help but think you're getting a close-up of the home life of our dear Robert Mapplethorpe. "Eddie stands up. He walks through the cut-up loft, looking for something to photograph. But there's nothing. Except this white lily flower in a black onyx vase. He doesn't want to photograph it. Why not? But he breaks through that feeling and grabs the vase in his hand, feeling as if he's sticking his hand through a plate-glass window. Can't make any phonecalls. The switchboard in his head has stopped lighting up.

"Eddie walks slowly back with the vase into the studio room. Puts it on a wooden high stool. Takes its picture.

"The lily looks cool." I suppose the seduction of transparency, "sticking his hand through a plate-glass window," lured me into this web of sin in the first place. In September, 1988 I wrote to Whitley Strieber, the horror writer whose latest books detail his thesis that ordinary Americans, men and women like ourselves, have been the victims of sex experiments by alien creatures in UFOs.

After receiving my letter, Strieber wrote back consolingly, advising me of a support group for people in my area suffering from my problem. I learned one lesson from this exchange, there's help for everybody. As Joe Orton said, "Nature excuses no one the

freaks' roll call." And I'll copy in this space back and forth from my original letter:

> Dear Mr. Strieber,
> Twelve years ago, I was 23, a waiter in the North Shore town of Smithtown, Long Island. I'd been visiting my parents on my way to work, and as I drove away from their house a startling thing happened. As I made the left turn out of my folks' subdivision onto Route 25A, in a desolate, woodsy area, I noticed an ice cream truck farther ahead on the highway. One of those trucks like "Good Humor" that parades around suburban neighborhoods playing jingles with jingle bells. This sight, combined with the sound of those little bells, froze me in my tracks.
> This was summer, June 1, 1976, just before twilight. The setting sun seemed white and cold, a big ball of snow on the horizon above a line of blue trees. Suddenly I ceased to be an adult and became a child again, a child four or five years old.
> I was swimming in some kind of deja vu experience. That, at least, is the way I rationalized it afterwards.

In "Satan" the photographer torments his model by forcing him to listen for long stretches as he reads aloud from Melville's *Benito Cereno*. I saw so clearly how all our stories are piled up on one another now, the way you or I can think of two things at the same time but with a corresponding lack of definition. How often have I envied people who have two TVs, they can watch two shows at the same time, but then I always have second thoughts and say I really wouldn't enjoy that. When I was 23, though I had my epiphanic moment watching the ice cream truck, I never gave my feelings much credence, I think partially because I did own a car and thus could slink in and out of situations like the Pink Panther in the cartoons, and I want to give a cogent example here, my love affair with Ralph Isham. I don't know why I slept with him in the

real sense, but I had my reasons. Two of my friends lived in the house next to mine, Ron and Becky, in a trial marriage, but almost from the week I met Ron I felt a crush on him so strong, so statutory that I didn't think of him as a friend but as a source of light and heat. That he was planning on marrying Becky I tried to put out of my mind even as I threw myself into their wedding plans ass over teakettle. Their house was even smaller than mine. You couldn't sit waiting for Ron to come out of the shower without a few drops of water passing the beaded curtain that served as a bathroom door, and hitting you on the arm or leg or head. His favorite TV show was the "Battle of the Network Stars," and to this day I'm fond of it too, and my favorite network is still ABC even though NBC has had far better shows, such as *Santa Barbara*, which I'll get to in a minute. I always root for ABC when the network stars do battle. "They film this at Pepperdine University in Malibu," Ron said. "It's a fantastic school, Kevin, you should go there, maybe they have a graduate program in English." Years later I went by Pepperdine on the bus to Hollywood, and I looked out into its silver beaches and its trimmed playing courts and Denise Venturi architecture and thought of Ron. But this story isn't about him, or hardly, it's about his uncle.

Ron's uncle Ralph was a caricature of a man, a twisted jumble of body parts, he walked and talked quickly, like he was trying to sell you something, and when he spoke he used a high voice like a tape whirring in super speed. I mean my own voice is high but his was the kind only dogs can hear. When we made dates on the phone it must have sounded like Yma Sumac talking to herself in some South American birdland. His wife was called Brooksy, by everyone, even the Mayor, and she collected replicas of the Statue of Liberty. Whenever any of Brooksy's friends wanted to please her, or say you knew her birthday was coming up, you were perfectly safe in buying her a replica of Lady Liberty, or a picture of it, or whatever, and she'd go bananas. Remember the hoopla when they restored the Statue of Liberty? I wished that she was still alive to enjoy it, when it began, when it was over, and now it's new and nice again like a phoenix.

The point is that Uncle Ralph used to delight neighborhood kids

by dressing up as Santa, and as I was discussing this story of mine with other people, three of them told me the same thing—each was involved with a sick man who liked to dress up as Santa, so it started me wondering if there are any *normal* people who like to play Santa, and I decided, on the whole, probably not.

The salient thing about Santa is that he comes down the chimney and leaves these toys. One body of material places him in a workshop at the North Pole, lording it over elves and reindeer, but in my opinion these are corruptions of an original text in which this big man just comes out of nowhere, leaves you toys and takes some cookies and milk from a little plate, then vanishes.

And so I shall reflect in this manner. On *Santa Barbara* Mason and Julia were trapped in this snowstorm on Christmas Eve and they had to seek shelter so they knocked on the door of this ordinary suburban house and this man answered the door, and Dodie said, "I bet he'll turn out to be Santa," and I thought, "He looks just like Uncle Ralph." She was right, I was wrong, but it made me think, the first ingredient in any good soap.

I had met Ralph several times at family parties and get-togethers. I never thought he was gay. On the day of Ron's wedding I saw him again, dressed in a puffy powder-blue suit, a kind of tuxedo from the sixties, and I began to drink heavily at the country club where the reception took place. Out in the sun the planters' punch I was drinking went to my head first, then to my bladder. This compound of elegant facades and white stucco pillars had its share of charm and urinals, but I couldn't find either, not at first. "Excuse me, is there a bathroom around here?" "Men's locker room, that's closest." "How novel," I said, I mounted the stairs and started to climb, gripping the white bannister for dear life. Through the tight seam of my black pants I felt a few fingers up the crack of my ass. I looked back and attached to the hand, Ralph's face came gleaming up at me like this elderly Howdy Doody puppet's. He was grinning like he knew some kind of secret. "Going to the head?" he said.

"If I can find it," I said.

"You can piss right in my mouth," he told me. "Any old time you've got the notion." This bold way of speaking, coupled with the hand in my ass, convinced me there was more to this guy than a funny voice and a wife who was a collect-a-holic. I moved my hips in such a way that I led him up the stairs as if into a space capsule that has somehow landed on the White House lawn, or the end of *Close Encounters*. I don't have to tell you how he got my phone number and started calling me up every day and every night until Mickey started to get suspicious. Anyhow it's all water under the bridge like so much other memory and experience. I started to piss and he held open his mouth to swallow me up whole without a choke or gargle, I figured, "It's these old ones have the stamina," because Uncle Ralph was sixty Ron said.

Mr. Strieber, I told myself the sight of the ice cream truck had brought back, in the way of classic Freudian analysis, a buried childhood trauma. But this memory in turn I'm today convinced was nothing more than a screen memory. Yet this is what I remembered:

I was four or five, an ice cream truck rolled up to our house where I lived with my parents, and I was lured away by its driver and placed onto the passenger seat of the cab. I made no protest, my mouth was filled with ice cream. I was a self-possessed child. So long as my mouth stayed full I didn't care what happened to me. The driver of the truck was a large man in a white overall, wearing glasses with dark lenses. He kept driving, bells ringing and merrily jingling, farther and farther away from my home. Finally he pulled into a deserted forest clearing, at which time I was removed from the passenger seat and put inside the truck, into the refrigerated space where the ice cream pops are kept, and molested there.

All this came flooding back to me as I sat there behind the steering wheel, my eyes flooding with tears and my heart pounding a mile a minute.

I told myself that this buried memory must account for a lot of the troubles I'd had growing up. At that time, the mid-70's, you were just beginning to hear about the apparently

endless cycle of child abuse and sexual victimization of children. I counted myself one of them after this flashback. And although some of the details seemed bizarre, I chalked it up to the nature of the child/sex experience.

As the years went on, however, I began to doubt my own recollections of this event. For one thing, I couldn't make myself believe that a sex criminal, no matter how deranged, would climb into an ice cream truck freezer to do so. I dunno, what do you think? I realize you don't pose as an expert on sex crime, Mr. Strieber, but you're a man of the world, possibly of more than one world, right? Give me some feedback if you'd be so kind.

"Oh, God, I don't know why I get myself in these things," I told Mickey. Actually I knew very well, or sort of well, but it's more dramatic, I think, if you keep yourself out of it. "I have to meet Ralph tonight."

Mickey was this guy who, well, I guess you'd call him my boyfriend. He was from a wealthy family in Connecticut, and I had met him here in San Francisco, then he returned to Long Island to live with me and follow me around like a puppy dog's tail. His mom and dad were social climbers who would have preferred him to enter Yale after Choate instead of escaping to Polk Street and poppers. Mickey distressed them by preferring the seedy side of town, it didn't matter which town, out of a hankering for some real experience—what the French call *nostalgie de la boue*. Not that Smithtown has a real "seedy side," but it did have me and it did have Ralph, Ron's uncle, whom Mickey had never met. His name was Mickey Manzl, and this similarity to the name of the famous Yankee slugger made some people remember his name, and made others forget it. When I was in a bad mood, which in those days was often, I would carp at him, "Why not call yourself 'Michael' like every other homosexual?" Anyhow I went out with Ralph at least partially to keep Mickey aware he wasn't my only source of sex knowledge, sex comfort. Every time I left the house his eyes would darken and narrow till they resembled two

dried up old peas. For he had come 3,000 miles, buoyed by my promises, to be treated instead like the dog's dinner. Still he kept saying, "yes," as if he really thought love could change me.

Bedstead:
From a knot of inch-thick rope the boy's hands dangle like dogs' paws. "No fair," Ralph thinks, elated. He wipes his palm on the bedsheet. Awkwardly Mickey's head tilts to one side, a block of bone and hair and sleep perched atop our tired flat pillow. One hip lies atop the sheet, and out of tension the other stretches north by northwest. If the hips were hands, hands of a clock, his ass would say seven-fifteen. And if so, the time would be wrong, since it's only about one-thirty p.m. (EST).

Two thin lines in the boy's naked stomach tilt, diagonal to match his distorted frame, one under the nipple, the other just under the navel.

If these lines were the hands of a clock the time would be about ten to nine. Fuck this hands business, the boy's half-dressed in white underwear, and looks hapless enough even for Ralph. From the open fly pubic hair protrudes a little,—cherry hair, with a bead of sweat glistening in it: sweat, or some other clear liquid? (Tears?) His long legs are bent at the knees like a stork's, and one hard heel digs for leverage into the soft thick mattress pad. There's a lot of confusion in his posture, but all Ralph can see is his allure. On a little side chair a cat crouches, filled with tension and thirst. Mickey feels the slightest bit of sex excitement he can possibly register, as though someone in another room were talking about sex. His throat feels tight and cold.

So there I was at Ralph's house one evening—Brooksy was visiting relatives in Milwaukee, and it must have been summer, but I remember vividly Ralph taking the Santa outfit out of a wardrobe and showing it to me, and I asked him to put it on for me. The radio was blasting, *Der Rosenkavalier*, the torrential renunciation of the Marschallin. "You want to see Santa?" Ralph repeated, his eyes lit up by happy flames. "I'll show you Santa."

Command performance? *Noblesse oblige*? First he showed me this

awful nude body, then wrestled it into this girdle with attachments—he was into rubber in general—and then into the girdle's chain link he inserted the various pieces of durofilm padding that gave all his convex parts new contours of fat. As he swaggered through the house drawing the curtains, he looked like the victim of a terrible burn case. Then these long johns, with the crotch cut away, and the red flannel suit, trimmed with white fur. Around his false waist he wrapped the kind of wide, black, vinyl belt Edie Sedgwick once wore. He was padded all over, except at the groin. "Is that what all Santas wear," I asked, "their cocks and balls hanging out at the crotch?" "You ever sit in Santa's lap?" he said, waving his limp red hat. "Then you must have felt him through the red velvet." "Don't little kids mash you with their heels?" "So what?" he replied, as he pasted on the beard that completed his drag. "What if they do? It goes with the territory." His big black boots Sylvia Plath described in "Daddy," so picture them stamping and mincing in your direction while all you're trying to do is knock down enough Dewar's to stay sophisticated. In the first *Anniversary*, Donne says the body's a "poor Inn, a prison-house packed up in two yards of skin," and in Ralph's case that was true, except make it "three yards of skin." He was a cheater and, like all cheaters, had made a precious gift to himself—he was able to think of two things at the same time: his own safety, and his own pleasure.

<u>Want</u>:
Ralph wants to give Mickey a little of everything he's got, like a dim sum cart. One from Column A, two from Column B. Not a lot of any one thing, but generous. "Howdy." Ralph twists the body before him so that its ass swings around, upward, then with both hands grips the waistband of the undershorts. With an ease that appalls him, he splits the fabric in a V down to the thighs, so that both halves of the ass lie bare and undignified. This is what Ralph goes for, this sense of power and apathy. "Ready to roll?" he shouts. I watch his hand move up and down from a distance, trying to figure what Mickey is feeling. If I had just gone to prep

school maybe I'd know.

Between the cheeks of Mickey's ass, the hand stops and looks around for five minutes, prodding and nibbling till it's been spread pretty far apart, maybe six inches. "I feel good?" Ralph asks, not to me, maybe to Mickey, though maybe to himself.

He sees this thing in there, this thing . . . makes him wince it's so repulsive. Still, it's what he goes for and has been for decades now. It's only about an inch long, and no wider than a paramecium. Slight hairs and puckers give it the unthinking look of a—caterpillar, or something else from the world of nature.

Ralph looks away from it for only an instant. The cat's observing him cautiously, intense interest plain in its pale green eyes. It's a warm day and my bedroom is hot with sun; the torn windowshade in a square yard of sun like a warm griddle mounted on one wall. Around Ralph's plump hand Mickey's warm skin blushes. Ralph's cock has the sheen of marble to it, I sit there wondering if all sixty-year old men stay so hard. Purple, pink marble, its base a flat place like a tombstone or relief. "It's the old ones," I think: *you know—Picasso—Chaplin—William O. Douglas.* . . . Ralph ignores me, while Mickey stares in my direction without seeing. First his asshole seems tight as a seam, but once dug into it opens, irrevocably as a can of beer. Around its mouth the taut glossy skin weeps red and pink, like the fabric rain slickers are made from. Ralph watches as Mickey's knees slide further apart, helter-skelter, but slow, and his throat touches the pillow with a certain majesty of defeat. "I'm open," Mickey thinks. Like the wallet you find in the trash after the pickpocket's done with it.

"I'd like to meet your little friend sometime," he told me.

"He's not so little," I said. "He's taller than I am."

"You know what I mean," he said, staring past me. Oh, I knew. Mickey's green eyes and chestnut hair attracted all kinds of geezers, I used to think he reminded them of Joel McCrea or someone of a bygone era.

Ralph nodded, turned the radio low. "And I'd like to meet him in a very specific way," he said coolly. "Do you think he'd be into it?" He liked to get me drunk so I would piss more, often enough he'd buy me

a case of Tab at a time, and a bottle of Johnnie Walker Red on top like the bow to a Christmas gift. I'd stand over him like the Statue of Liberty, give me your huddled masses, I'd say, yearning to breathe free. I'd see his little fists going up and down and I'd know I was pleasing. I said, "You are wrong, this is wrong," without taking the time to suss out what was wrong or right about my behavior or environment. I knew there was something kinky about this relationship, but whatever it was, there wasn't enough of it. "Something," the noun, was too vague: I wanted a whole novel to open like *Call me Ishmael*. "Let me tell you *how* I'd like to meet him—or is that too much to ask?"

Why these are the words every lover wants to hear, is this too much to ask! I was excited, it smelled like trouble.

> Then two years ago another experience made me doubt my own sanity. I woke at six a.m., a strange white light covering my room. An intense chill filled the room, yet I was sweating. The walls were white like they'd been dipped in frost. It reminded me of the inside of a huge refrigerator.
>
> Although I can't explain why, right then I knew that what had happened to me in my childhood had not been a case of sexual molestation, not in any ordinary sense anyhow. No, I can't explain how I knew. But some alien presence had been in my room!
>
> The impression of a powerful force for evil remained with me for days.
>
> I thought back to my mental picture of my molester. His eyes, hidden behind the almond-shaped lenses of his glasses; his white suit, which I had thought part of a uniform, suddenly reassembled itself into the protective garments of a lab technician.
>
> The frost that had surrounded me that day, and on the night I speak of now two years ago, I now re-vision as being part of a much larger space than the confines of a Good Humor truck. Bigger than any bedroom either.

These spaces were only the re-castings my mind had worked on the real space into which I was abducted, a space much vaster than I could take in at the time.

His face didn't much resemble the face on the cover of your book *Communion*, although it shared the same blank black eyes and skinny lips, the elongated ears and the bulbous head. There was some kind of shiny metal apparatus dangling from a belt around his waist, which I misfigured as the kind of change dispenser ice-cream men wear on their rounds. But it was not meant for dispensing change: that I know now. It contained some kind of battery or Geiger counter, buzzing and whirring and emitting electrical impulses I took for sexual ones.

Inside the humid hole Ralph's thumb begins to revolve, a blade in a fan. Or "key in ignition" might be better. Mickey's breathing, so is Ralph. The air that expands their lungs beams a cold blue light, the color of peace and science. Ralph's stubby fingers touch the rags of underwear that dangle still from the boy's red thighs. Give them a little yank. Above frayed cotton the pink warm skin glows under the marks Ralph has made, pulsates white and yellow: pastoral colors. Without much finesse Ralph works his cock up to the vicinity of Mickey's ass and wriggles till he's pinpointed it. He leans over: his lips meet Mickey's ear. "I'll make you a star," he says, mouth dry. There's a ridge of muscle on the back of Mickey's neck Ralph now watches. He guesses it must come spontaneously to the skin of a boy who knows he's going to be fucked. Yet this same ridge, which Ralph likes in a way, suggests any number of dispiriting negative outcomes, as does the fog, clammy and cold, that seems to emanate from Mickey's shoulders and shoulderblades.

At Ron's parents' house, at Thanksgiving, I'm invited as a family friend, and when I got there Ralph and Brooksy were entertaining everyone with details of their latest day trip to Liberty Island. I felt ashamed that I was seeing him. He didn't make matters any easier by following me into the bathroom and trying to sit on the toilet bowl

when I took a leak. "Get the hell away from me," I told him, "or I'll aim for your face instead of your mouth." Through the thin plywood door I heard the TV, an announcer announcing the holiday classic *Miracle on 34th Street.* "That's my movie," he said to me blithely, and he left. I stood there looking at the foggy mirror inhaling and exhaling me like cigarette smoke. "Two can play at this game," I thought, and I went out and ate two pounds of turkey and most of the oyster stuffing. When Santa comes down your chimney it's exactly how I feel when I get fucked. This enormous invasion. It doesn't happen any more, to me, so I think of it as a belief system, like the Great Chain of Being, once in everyday use but now an Elizabethan relic. I draw a windowshade over the events, every day I look up and wonder what happened to the last man who put his dick to me.

That's okay. It'll pass. Leaning over his prey, Ralph tries to come in, into Mickey's little clarinet hole. Mickey cranks back his head and blows a foul breath at him, and for his pains gets a poke to the jaw. Then Ralph takes both hands and shoves himself into the miniature hole. Like miniature golf, he thinks. "Pretend you don't like this," he says. His knees feel pleasantly warm with friction. He's beginning to work up a sweat, as you might from a nice morning set of tennis.

"Won't have to pretend much," Mickey thinks, hanging from his hands by the rope. The rope abrades his wrists and begins, ever so surely, to cut off the circulation of his arms. I watch his hands turning this pale shade of violet. Straight down point his cock and balls, swinging slightly clockwise. Maybe if we were south of the Equator they'd swing the other way. Ralph raises Mickey's body up, by the armpits: this alleviates the pain a bit, the kink, but this small plus is negated almost instantly. "There's a big thing," Mickey realizes, "in my anatomy."

"Blow into it," Ralph urges.

"Can't." Mickey says. "Take it out, it hurts."

"Can't stop now," Ralph grins. "Make me come, it'll get smaller, I swear. Blow into it, squeeze me."

The cameras explode and harsh white light bathes their bod-

ies in sodium rays. These pictures are meant for Ralph's private reserve, the way his wife collects her Statues of Liberty on her sideboard and dashboard, he keeps these pictures in a tackle box in the basement. In another ten seconds a second set of flashbulbs goes off, then a third, because I'm no Edward Weston and I need plenty of takes.

In the ebb and flow of light Mickey's face freezes into a rictus. Was that the *atom bomb* he wonders. Ralph sees Mickey's smile and reckons he's found his prostate. In Ralph's eyes Mickey's a silver mine, a Comstock Lode. With enough pioneer spirit, elbow grease, who knows what might be brought out of him? "Can I cut a little piece off your ear lobe," he says quickly. "No way," Mickey snorts. I jump out from behind the cameras and wouldn't you know it, the cat starts howling like it wants some Kitty-Os or other cat treats.

In our alien encounters, these creatures with triangles for faces and holes for eyes come to us at midnight. We don't object to their sex experiments, no matter how outre! Over and over Strieber outlines the shock and horror a good hypnosis produces, the subjects can't believe such outrages were performed right on their bodies without their consent or remembering them. In Strieber's own case a long metal tube was passed eighteen inches into his rectum to collect G-I specimens of the X description, yet he did not remember this. What about anesthesia in general? You're lying down on a silver table and figures pass by you with hands long as knives, fingers dextrous as Balinese dancers. The ceiling is studded with the whizzing blue panels of Nintendo games, and you play both victim and star. In your backyard the next morning a huge circle of scorched earth reveals the place of your trauma.

Earlier in the day I'd pressed Mickey's wrists together neatly, crossed them left over right, for that dog paw effect I wanted. "Why so tight, Kevin?"

"So it'll look natural." I said.

Natural? Well, "kidnapped," actually. "Ralph saw this one time in a skin magazine." In new white underwear I'd bought for him at the Army-Navy stores, I had to go all the way to Flatbush to buy just the right kind. *The things a mother will do!* "Bring your balls up," I sug-

gested. My eye pictured a gourmand's feast of balls, big Brussels sprouts but tastier. Not these drab walnuts for goodness sake! "Make them big." "Can't oblige, I don't know how." I wasn't satisfied with the effect, but due to time pressure had to let it go. "Pretend you're in a movie," I said, "and you've been kidnapped. Or pretend you *have been* kidnapped. Whatever's easier." His studious face wrinkled in thought, trying to decide. Presently he brightened up. "I could pretend that I'm in this horror movie and I've been kidnapped by space aliens," he said. Taking a nail scissors, I snipped three fly buttons off the shorts, and slit along the cheap elastic of the waistband. You never know, do you? You try to prepare for every eventuality, but 'twixt the cup and the lip there's many a slip so what can you do? "I just want you to act terrified." Out from the fly I brushed his pubic hair so it would protrude a little, artistically as was feasible with seeming unplanned. Just like any other kidnapped kid, drowsy, scared, engorged with excitement.

I was in charge of his every motion. Even his stillnesses, which aped his death, were mine to chew on.

I thought there'd be drama in this tasted, sealed thing. Instead his taut body skewers my intention. I miss him now, like a shish-ka-bob you'd munch from, then put down, full. He moved away from me, decided to want another life. On a bed of rice I lay him out, and savory juices dripped brown and red to stain my white food starch. Food nauseatingly warm and viscous, sweetly rancid if sniffed at hard, otherwise the no-smell of water or nylon. He looks at me through these drawn eyelids, like peels of onion or nonseeing glaucoma. Narrative implies choice, it's a Miss America pageant readers pay to judge. In this story who's the best? Him or me? I say "me." I'm looking at him sideways, upside down, every which way: he's not to my liking—send him back to whatever kitchen he came from, sorry but *no appetite*. What future had Mickey with Ralph? Only a chiropractic problem, a taste of metal, a few bright sores some salve could soothe. I felt like Elizabeth

Bennet in *Pride and Prejudice*: "How little of permanent happiness could belong to a couple who were only brought together because their passions were stronger than their virtue, she could easily conjecture."

Conjecture:
On Ralph's side I knew first, that he was a man deeply dissatisfied with life's lot. Life was too fast for him, and because I was young I believed sincerely I could slow it down to the sensual gift he gave me. I once asked Ralph if he had any idea why a bound boy excited him so. *And also that Latex!* His gaze shook a little, a tremor, then he faced me with an open glad smile. Turned out his mother and sister used to tie him to a tree, when he was, say, five or six, when they went shopping downtown.

"That's it?" I said blankly.

"I like rope," he said. "I can still remember this old quarter-hemp twine they used."

"Did anything ever happen, I mean, when you were tied up?" *Maybe he'd been molested by some neighbors* I thought hopefully.

But apparently not.

A gag didn't really do it for him. He could have stuffed the cat down Mickey's throat and it really wouldn't have added to it. "Because they never shut me up," he said, with a reminiscent shake of the head. "No, sometimes I hollered so loud I got hoarse the next day."

Of Mickey's virtue I knew only that from the beginning of our intimacy he had been anxious to please, a white boy, with a heart of white gold. When I pushed the planes of his face downward, I saw both a long learning and a long forgetting. He pulled up his sleeve, to show me the empty space where boys in our neighborhood wore tattoos. Two square inches of flesh and tissue, blank as a circumcision. Two square inches where Ralph set his teethmarks in penetration. I poured him a glass of scotch and water, the world's flattest drink. "Welcome to Smithtown." For Mickey Manzl "passions" were the mediation we, the others in his life, placed between our knowledge of his body and our rejection of it. "Sorry there's no ice." I wanted to implant his body, toes first, into the ground and set him up a signpost, like the man going to St. Ives. He was the subject of my sentence,

caught up in youth like a paper airplane caught in the wind, but unlike the paper plane he hadn't the skill to come down from his medium. As a "subject" he was thus perhaps *too supreme*, for alas, like all others my sentence needed a verb to keep going, and this his beauty would not allow. How then could he allow himself to be treated this way, on my behalf and on my say-so? This "act" of passive sodomy was the passage I predicated, this conjecture my predicate. I told Ralph one thing, Mickey another. That's my way. I am led through a corridor of gray metal, through my veins green bug juice or plasma is fed. As I walk a blank steel panel opens before me and inside my head grows a new space where a thought used to be, then another, soon I'm filled with enough air.

I'm content enough, like a bubble envelope. I lie down on my back and my hands are taped with black stickum gum, "relax now." I tell them where I live and how I used to watch *Santa Barbara* every day. And out from my mouth they extract my teeth, then begin their excavations. On the ceiling there's some famous stars or windows of the far night. I'm breathing in, not breathing out. The air's a faint blue, the color of speed and peace. Into my incision they feed a tickertape receipt imprinted with the false memories I'll afterwards connect to. I left out milk-and-cookies, not my missing diamond bracelets. I did not have that baby in high school, instead I spent the summer in Europe. I did not see that little chestnut boy, instead a man in a short white sportcoat sucked my cold little dick like gumdrops. I did not write this, this was my life, or vice versa. Me? I'm not from outer space, or even from out of your mind, I'm from the North Pole, Santa's Workshop, and I'm the eponymous Santa!

Every day I get up, get dressed, go to work, a little piece of me is dying, I quit drinking, quit cruising, I'm trying to quit smoking: still it comes on, I get afraid of Satan. I remember when I was a kid once, like six or seven: spying around I noticed a huge heap on top of a shelf in my parents' downstairs coat closet. I got a chair and stood on it and found a million presents, the chemistry set I wanted, the ViewMaster reels, the life of Merle Oberon. Also

some other gifts that must have been meant for my brothers and sisters. What is going on I thought. Has the whole world gone crazy, *what about Santa?*

In the way of lovers, Dodie and I quizzed each other, *"What's the most unusual place you ever made love and to whom?"* My mind skittered over a dozen ugly places, finally settled on one, this old gray weather-beaten rowboat filled with fish, out in the middle of Long Island Sound on a cold April morning. Ralph and Kevin. Dead cold fish slithered up between our legs like Old Faithful sprouting, and some of them were still alive but cold, but that doesn't sound so unusual. It must have stuck in my head because of the gray of the bay, the gray of the sky, the gray of my skin, my little fish, my boat. All it felt like was semen, that is, the sticky wash of sex that goes on in one's head when one doesn't expect it to.
Ralph had stuffed his head with so much Eros it made him giddy, the way you feel swallowing the helium out of my party balloons. I couldn't get a grip on his thoughts about sex, I knew only what porn he'd read and seen. For him re-enactment was all, he was a book I guess, and at this I turned up my long beaklike nose deriding, with all youth's ferocity, his grievous lack of authenticity. What brought him out to this drunken boat? It wasn't the hunger for Life I prized. When I stretched out my hands fish, fat as stuffed sausages, crept under my fingernails. Hundreds of eyes and eggs. People eat this and I just fucked a birdbrain on it? "That was great," Ralph said. "Oh God," I told him, "you're so enthusiastic." "We have a group of guys, gets together," says Eddie, in "Satan." "You're supposed to recite the Latin Mass backwards. But most of these guys couldn't say their names backwards. So they say anything that comes into their heads. Dirty words. Curses. Spanish." I thought to myself, *boat. Fish. Unusual.* But the more I think about it, this setting was less unusual than it was a paradigm.

<u>Bill</u>:
Recently a friend died, and his mother found my name in his

address book, or on his computer, and called me up to tell me about it. Bill was the editor of the Natalie Wood Fan Club News and through our correspondence I'd gotten to like him a great deal. His mother, Sylvia, stayed with him in the hospital after all had fled, unnerved, I guess, by Bill's increasing lack of connection with this, our own world. At one point, she told me, he walked into the dream house from *Miracle on 34th Street* and told her, "There really is a Santa, Mom." In his last hours he saw her, Natalie, extending her hands to him across a wide blue border, like a ribbon of cloud, murmuring his name, *come to me, come to me Bill.* "I'm on my way, Natalie," he said, and his mother sat nearby and her heart broke in 2 two's. "I've been waiting for you," Natalie said. "I'm coming," Bill said. Natalie smiled, her intimate, glamorous smile, and the screen dissolved the way it does in *West Side Story* when Tony first sees Maria at the big teen dance. "We don't know much about life and death," Sylvia told me. "We don't know much about what keeps a person alive, do we, Mr. Killian?" "Don't call me Mr. Killian," I said, "Nobody ever calls me that, except, you know, telephone people who want to sell magazines." "She was his whole life," Sylvia said. "And now both of them are gone." —It certainly seems like a careless symmetry.

But here's a tip for getting rid of people who want to sell you magazines on the phone. "Have I reached Mr. Killian?" I always say, "Yes," because you never know. Then it turns out they will send you three years of *TV Guide, Car & Driver, Mademoiselle* and *Sports Illustrated* for the low low introductory price of only $49.99. "How does that sound to you, Mr. Killian?"

The trick is in sounding slow but thrilled at the same time. "It sounds great! But do you have *Radio Guide* instead of *TV Guide*? See, I'm blind and I don't watch any shows on TV."

"Well, I'll check with my supervisor. While I have you on the phone, are you married? Maybe your wife would like *Redbook* or *Cosmo*."

"Yeah, but my wife . . . she's retarded."

"Oh, I'm sorry to hear that."

"Yeah, well, you got *Highlights for Children*, she likes to color.

And you say you got Braille *Car & Driver?*"

"I'll have to check with my supervisor. We'll get back to you."

"Oh please do," I say. "I've been looking everywhere for *Radio News* in Braille."

I wasn't out till three in the morning: that was a nightmare you were having. I did not pass that bum in the street; I made him ham and eggs from my own kitchen cabinet. That buoyant love, that vernal stock tender, I did not refute, from him I was not absent in the Spring. Me? *I am a woman of heart and mind.* I stick my hand through a plate-glass window, the lily looks cool. Writing this down I feel so relaxed, numbers spin out of my head, ball bearings on your DC-10. Me? I was his whole life, and now both of us are gone.

Father and Son

(with Josh Cherin)

Kevin sat in the gathering dusk of the crowded movie theater, forty years old, hungover, more than a little out of place. His popcorn was a glowing dome of yellow flakes in a cardboard carton perched on his lap. His coat and sweater, piled up in the seat he was saving for his son, Josh. That didn't stop ushers from asking him to show his tickets, casting the beam of an intrusive flashlight all over the empty seat. All around him people were hooting in the dark. *I doubt if many of them are artists*, he thought dismissively. The screen was filled with colorful images of coming attractions, then old stock footage of Will Rogers, and various stars of today asking for donations to stop cancer. Then the lights came up and all these people started walking up the aisles rattling cans. "Well," he thought, "I'm not giving a penny til they start curing AIDS."

Josh sat on the ledge in front of the glassed-in posters outside the theater. He shaded his eyes with his hand, and watched the line collecting for the next showing of *Jurassic Park*. All the obnoxious kids waiting with their parents, little pieces of chalk screeching on a blackboard. He thought of borrowing money for the matinee from them, but after three or four parents turned him down, he retired back to the ledge, embarrassed, defeated. He rubbed the sleeve of his red flannel shirt, trying to make his goosebumps go away. This was the third time in a row he'd missed his father. Maybe there was some revenge principle working here, like his father was mad at him for merely being alive. "It's windy out here," whined a little girl on line, clutching her stuffed dinosaur doll. "Can we go inside yet? I want to see Tyrannosaurus Rex rip that lawyer off the toilet." "In a minute," said the authoritative parent. Josh cringed, and thought of leaving, thought of going back to his studio. Maybe calling his father's apartment, seeing if

he was there. How about a crank call to really bug him? He could say, "Kevin, Kevin, I want to lick your pussy,"—in this low masculine voice. Or: "I know where your furniture is,"—pretending he was a psycho killer. The sky was a bright cerulean blue above his head. Thin clouds scudded rapidly across the bright cerulean sky, wide and mutated, a mirror of the city, only completely white. Josh looked at the cars on the street and thought of walking all the way back to his apartment. It must be over a mile. And he was lazy. And getting old, already twenty-one. A girl in a blue Pontiac stopped at the red light in front of the Rio Theater, and turned her head, then waved, recognizing him. He looked back at the theater door and the usher guarding admission. Hoping the light would change. He knew her too well, which she confirmed by waving again and honking. Shit. He was caught.

Coat in tow, Kevin approached the candy counter, squinting. "Can I speak to the manager, please?" "That's him over there with the dreadlocks," replied the obliging candy girl. Resolutely Kevin walked to the Rastafarian-type guy and asked for his money back. "I don't come to the movies to be hit up for spare change. If I want that I can stay home and sit on my stoop or go to the ATM machine." The manager looked down at him pityingly over the rim of his dark glasses. Kevin wondered if he were blind like Stevie Wonder. Just then he heard a thumping and the exit door by the ticket booth rattling. He couldn't see who it was through the shaded glass doors. But he knew it must be Josh: who else would be yelling, "Dad! Dad!" into a vacant lobby? His face brightened before he remembered how upset he was with Josh. "One minute, son," he indicated with a finger, then turned back to the manager. "I want my fifteen dollars back right now or I'm going to the Better Business Bureau." "Okay," said the manager. *He must see all kinds of kooks, I'm far from the worst.* "And also here's my popcorn back, how do you expect a man to eat with all that cancer on the screen? It's disgusting." Kevin's temper was flaring and he knew it.

Outside the theater Josh pounded on the glass, yelling for his father. He didn't want to risk waiting outside a minute longer. But

then he heard footsteps coming up behind him. He felt guilty like Raskolnikov, a prisoner of his own diseased imagination. A hand touched his shoulder and he jumped a little. "Well?" said Sandra, superbly. "If it isn't the infamous Josh de la Foresta." "Oh, hi, Sandra," he replied, "how are you doing? Still driving that blue Pontiac?" She grimaced at him, like the McDonalds purple mascot, her green eyes misty with emotion. "It's a piece of shit," she admitted. "But what am I supposed to do, walk, like you?" She ruffled his hair, and bent down to kiss his cheek. "I hope what happened wasn't too hard on you. I thought you would call." Her gaze drifted over his shoulder to the scene in the lobby. "Who's that with the popcorn, looks like he's about to have a stroke or something, how gruesome." "You going to the show?" said Josh. "No, are you?" "I don't think so." Just then he heard his father yell, "Josh," and he spun back to face Sandra. "Do you know him?" said Sandra. "No," Josh said, "I don't know him. I think the manager's called 'Josh,' too, somebody told me that once." "Well anyhow," said Sandra, "I could lend you the money, what do you need, a dollar? You could take me along: a real date." Josh thought of all the times Sandra had given him things, saying they were loans. Last time he had been short on his rent, and she had made up the difference, then started to move in, a few things at a time. He wouldn't have minded, but she kept bringing home other men, and he hated sleeping in a crowded bed. That was the last he had seen of her and he still had a carton of her records. Which he hoped she had forgotten. Mostly Talking Heads. "No thanks," he told her. "Josh!" his father called again. "You sure you don't know him?" Sandra asked. "Kind of," he admitted under his breath. Sandra rolled her eyes. "If you want to play mysterious that's fine with me, Josh. But I don't have time in my life for your shit, I told you that when we lived together. I'm sorry but that's the way it is. I'm leaving San Francisco in the morning, forever, and I still have to pack my records. You still have that box?" "Somewhere," he said. "Do you have a shipping address?" "In Tangier?" she cried, a little note of disbelief in her voice.

 Kevin watched Josh, wondering who the woman towering above him could possibly be. *She's six foot one if she's an inch.* He couldn't imagine what she wanted with his son—*unless maybe a footstool or a*

place to rest her drinks. "Josh!" he called for the fourth or fifth time. The manager said, "Jah mon, this popcorn's gone, I'm not givin' you any money for empty box." "All right already," Kevin snapped. "Just open the door there and let my son in. The white boy in the red flannel shirt." "Who's that with the boy, Patrick Ewing? She's tall as a maypole." Kevin thought, *if only I knew who Patrick Ewing is, I could get some respect.* But he didn't. Oh well. "Please, manager, help me save my boy, let him in right away. The credits are starting. And that woman looks dangerous." "Don't worry," said the manager wisely. But he went to the door and let Josh in, telling Sandra, "You pay your money, you wait on line, we're sold out til Tuesday."

Josh smiled and waved as he was pulled into the theater. "Well, what day is it today?" cried Sandra. "And what about my records?" "I'll send them to Tangier," Josh called through the glass. Suddenly his father was in his face. Glowering, the bags under his eyes dark and dirty-looking. "Where have you been?" demanded Kevin. "We were supposed to meet an *hour* ago at Happy Donuts." Josh said nothing, just nodded and looked at the bright and colorful candy counter. He wasn't hungry, he just wanted something. Kevin added, "I suppose your mother was behind this." Josh said, "Yeah, she's behind everything." "Who was that tall blonde girl you were talking to?" "A friend of Mom's," Josh said. "It figures," said Kevin. "She never had any taste in friends." "Dad," said Josh, "can we just cut the autopsy, I bet the movie's started already." "Oh who cares," said Kevin, "I've seen it twice already, waiting for you, if you recall. And besides, we're getting our money back." He looked for the manager but couldn't spot him. "Is this a movie you really wanted to see, Josh?" "I don't know." "If it is, we can go in. If not, let's wait for the manager." They could hear the dinosaur screaming from inside, and Josh thought, "Yeah, I want to see the movie," but said nothing. "This is the part," Kevin said, "where the dinosaurs start getting revenge." Josh tried to look interested, not angry. Kevin said, "A lot of really cute guys come to this theater, have you noticed?" "No, Dad, not really." Josh hoped they wouldn't fight again about

what each of them did and didn't notice. "You should keep your eyes open more often. You'd learn something." The lobby was cavernous, with high pitched ceilings you couldn't really see the top of, and the walls were covered with mosaics of movie stars, like the Sistine Chapel. There was a counter selling *Jurassic Park* souvenirs, and a man behind it with a shaved head and a black T-shirt, "Bio-Hazard" printed on it. The carpet was red and dusty, as though a small flea circus lived in each square inch, secretly, with the aplomb of the invisible. "You on drugs?" Kevin asked his son, who sat there rubbing his face with both hands, shaking his head. "Drugs are fine, just do them the way I did them."

Josh was trying to remember why he had missed the last two movie dates Kevin had set up. One was last Sunday, where had he gone instead? *I should keep a diary, I'm a busy stud par excellence, Josh de la Foresta.* Had he been at the club? Was he still seeing Sandra, packing her endless rows of Talking Heads vinyl, David Byrne's peculiar face glaring sociably from every sleeve? Aloud he said, "Sorry I missed you last couple of weeks."

Kevin felt his head begin to buzz and noticed the "RESTROOM" sign going up the plush stairway. He had this scratchy sensation at the base of his throat which he had come to associate with his occasional meetings with Josh. He wanted a drink, but he didn't want Josh to know. "How about a drink?" he said. "Want me to get you a Tab or something?" "Sure. But I don't think they've sold Tab in movie theaters since like, 1950." "Well, what do you want?" Kevin asked irritably. "Mountain Dew?" "Can we just go somewhere else?" Josh said.

It always got to that, what did Josh want? Sometimes Kevin felt like a usher in the movie of Josh's life, shining the flashlight of curiosity into his son's desire. There was never anything there, just a black stare, like a rabbit caught by the headlight of an oncoming car. Were all kids like this nowadays, so non-committal, so non-verbal, so stupid, or was it just Josh? Or were they hiding it from him? Josh was an accident, the result of a drunken episode Kevin couldn't even remember two days after it happened. There'd been so many drunk afternoons when he was nineteen. The best years of his life. He had married Michelle more or less on a whim, driving her in his Volkswagen bus to marry her in Reno, where, two years later, she divorced him, sleepy tod-

dler in her long pale arms. "You're not cut out to be a father," she said, and he'd spent the next 20 years proving her right. And always wondering if Josh would ever forgive him. "Hello! Are you there?" he said now to Josh. "What?" Josh said, jumping slightly, startled. "I wasn't paying attention." "Where's that fucking manager," Kevin said. "I'm not made out of money, I'm an artist." "If I find him, can I have a dollar?" Josh asked, standing up. "You wait here," said his father. "I have to take a leak. I'll think about that dollar." Then he mounted the stairs, picturing the bright lights of the men's room, and the glossy urinals, and the privacy. He touched the pint bottle of whiskey in his coat pocket. He definitely needed a drink, and maybe a little blow.

Josh remained standing aimlessly. When the manager came up to him, a few minutes later, he explained, "Uh, my dad's in the restroom, but he wanted you to give me the refund, honestly." "No can do," said the manager. "Here's two passes, come back again and be on time." "Thanks," said Josh, a little let down. His father would be disappointed in him. As usual. He could never do anything right, no matter how much he wanted to please. There was always a failure. The pot at the end of the rainbow, rusted. Even his being straight was, he knew, something of a disappointment to his father. Another thing they couldn't share. Josh remembered being about six years old and his father's roommate telling him, *we're in love, we're a couple, we're like man and wife*. That was a shock. Not like he knew what the guy meant or anything. His mother didn't let him see his father for two years afterwards, until the court hearings were over. Then she had to. "I hate California," she said. "It's too liberal. It might as well be Oz." So then his dad began taking him to the movies once a week. And going to the park afterwards, where he would sip from a brown paper bag, like a bum. And so on for the rest of their lives. Josh wondered if Kevin had gone upstairs to drink, and that saddened him. Though it didn't really matter.

He hesitated at the foot of the stairs, leaning on the brass banister while the whole audience screamed in terror. Then he jumped up the stairs, two by two, and pushed open the men's

room door. "Any cute guys?" he said as a joke. His father looked up from the sink, shocked, trying to get the cap back on the whiskey. The cap kept slipping around and around this tiny groove. "I knew it," said Josh. "You knew what," said Kevin, tucking the flask away, wiping his mouth. His eyes were frosted, opaque, expressionless; only the sudden blush in his cheeks betrayed him. Josh didn't know what to say. "You could at least offer me a sip," he joked uncomfortably. "Hey, dad, lighten up. I'm twenty-one, remember? I'm legal."

"Oh, Josh," Kevin began, but then the words froze inside of him. Which was odd, considering his usual poise, his famous verbal dexterity. He blinked and looked at his son, in his red flannel shirt, his sandals, his clothes, the way he stood. He had watched him grow up, little by little, usually from a distance. "Josh, I—"

"You what?" Josh said. "What is it that you never explain? You always stop there, and let it go. You answer with some joke, or change the subject, pretend nothing happened."

Kevin walked over to the bank of urinals, opened his pants, took out his dick, and pissed silently, onto this little white cake of mothball material which kept bobbing up and down like a head. Purposefully Josh strode forward, and asked, "How big is your cock," trying to see around the plastic protector. He remembered it from a long time ago, at five, standing in the shower, with his father's cock like a skyscraper right next to his nose. It couldn't be that big, not any more. He reached over and took it in his left hand, and grabbed his own with the other hand. "Ha!" he yelled, "mine's bigger, you faker." His father, startled, continued to piss over Josh's hand. Then there was the enormous rumble of a toilet flushing, and bam, a short well-dressed man came out of the stall behind them, sheepishly carrying an inflated six-foot dinosaur. To Kevin, this man looked strangely familiar; it took him about twenty seconds to realize why. "Josh, that's Steven Spielberg," he whispered. "Don't look now." Steven Spielberg looked at them with a certain amount of distaste. Kevin nodded as if to say, hey, this is San Francisco, where anything goes, but casually he tried to remove his son's hand from his dick. Josh was jubilant at finding out his father was only life-sized after all, and having Steven Spielberg as a witness was icing on the cake.

Josh opened the restroom door and made his way downstairs, leaving his father staring at the tile wall, his face the color that Celine called masturbation white. *Ugh, he's up there holding his dick in his hands, and I came out of that like he was shaking it off.* Josh fled into the auditorium, propelled by shivers of revulsion. Inside darkness enveloped him, just as Laura Dern sat down and Richard Attenborough calmly ate dinner, ignoring the fact that his grandchildren might be dead. Bored with human drama, kids were whispering for candy. He pushed his way to what he hoped was an empty seat. "Mister," said a little boy. "That's my mother's chair. My mother sits there." "Fuck you," said Josh. The boy's father leaned over with this big shit-eating grin. "Get outa here," said he. "If we weren't watching the movie, I'd kick your ass." Josh got the point and left the row. If this was family life, include him out. He stood in the aisle, way in the back, and brooded for awhile, but then the movie took over and he forgot about his own problems.

Kevin washed his hands slowly, the thin pink lotion cupped in his palms, the water bouncing from his hands into the mirror. "I feel like Pontius Pilate," he said out loud. "And where on earth is my autograph book when I really need it. This is *always* happening to me." For the first time he noticed the Muzak piped in through speakers placed discreetly as horned owls. What song was playing? He remembered it from his youth. It was, God, what was it? Something by the Beatles. "I Want to Hold Your Hand." He rinsed his face and stared in the mirror, talking to himself, saying all the words of the song in a low monotone. A really cute guy came in the room, but Kevin ignored him to a certain extent. "Some movie, ha?" said the guy, unzipping his fly, saddling up to the same urinal Kevin had vacated. "Seen it twice already," they both said at the same time. "Totally great," said the cute guy. Kevin remembered Josh's tenth birthday at Farrell's, the old-timey ice cream place on Grant. He'd just broken up with what's his name—he never could remember, there had been so many—and listened to Josh and his friends screaming through an ice cream fight. Finally he left for the bar next door. One thing led to anoth-

er and he didn't make it back for for a couple of hours. Josh had left his present, still wrapped, with the woman at the counter, and taken the bus home to his mother. "Yeah," Kevin said, "totally great. My son loves *Jurassic Park*, he's got all the merchandise." "Oh yeah? No shit." "I spoil him," said Kevin. "When he grows up he'll be rotten. Did you see Steven Spielberg out in the lobby with that blow-up raptor!" He pushed open the swinging door, into the cool cavernous lobby once again. Alone on the landing, he took another swig from the J&B. "I feel like a pervert," he said to himself, opening and closing his mouth. "Ha, ha, ha." "Hey you there with the bottle," called the manager, "put it away. No drinking in this movie house." Kevin lifted his arms as though to say, "I surrender," and slowly descended the stairs, trying to figure out how to track down Steven Spielberg for his autograph. But first should he try calling over to Josh's place? No, he wouldn't be home yet, the walk was too long. But he could leave a message. "Where's the phone?" he asked the manager, who sighed, trying to be patient, but obviously tired of him. "I have to make an important call," he added. "Business. My son, you see, is very sick. He needs his medicine. He needs AZT, know what that is?" "There's the phone," said the manager. "Yeah, well, what about my fifteen dollars?" Kevin shouted, once the glass doors of the phone booth had closed around him. "Fuck the fifteen dollars," he mumbled, dialing the number. One good thing about drinking so much is you know when you're drunk because it makes you so happy. The phone rang and the machine picked up. Josh's light, terse voice. "Hi . . . how are you doing? I'm fine . . . but I'm not home. Not that you'd know the difference. I could be here, I could be listening, so speak up. Beep."

Hurriedly Kevin spoke into the black receiver, willing Josh to come to the phone. "This is your Dad, I'm still at *Jurassic Park*, what happened? Are you there? Sorry about the bathroom. And I love you. Hope your roommate's not listening in, you, you jerk who never gives Josh my messages, so we keep missing one another. But I don't want to blame it on him, it's my fault, I fucked up, I keep fucking up. Wow, can you believe we saw Steven Spielberg! I'm waiting here for his autograph. I want to tell him, like, Laura Dern was all right but, Steve, can't you find something for Meryl Streep next time? . . ." The tape ran out,

cutting him off, and he bounced the phone down off its impotent little hook. After one more snort, he opened the doors to the phone booth and stepped out carefully. The manager was counting cash behind the candy counter, when Kevin walked up to him, frustrated and flustered.

"Where's my fifteen dollars?" he said. "I'm an artist, I'm not a Rockefeller, don't rip me off."

"Hey mon, your son, or whatever, took the passes instead, one for him, one for you. Then he went into the picture. He's got your money, little cheat."

"He is a cheat," Kevin said, drifting away towards the doors to the auditorium. "A cheat and a thief . . . He took my money and he takes everything I give him, never says it's enough." Kevin walked into the theater, holding the door open so he could see, until a few startled faces turned, ordering it closed. On the screen was a part he remembered from his previous viewings, waiting for Josh, always waiting for Josh. Two fat raptors were squirming their way down a flight of stairs, chasing two frightened children. "Josh," he called out in a stage whisper. "Are you around here? I'm sorry!"

"Ssssh," was the reply. He took a step further into the darkness. "Josh!"

Josh heard his father and slouched further behind the door. He felt as though he were shirking his responsibility to save his father from the audience. Not like Sam Neill rescuing the kids while their selfish grandfather worries only about the profits of Jurassic Park, and his investors' money. But he was no movie hero. Josh rubbed the passes together, ashamed of both himself and his father. He couldn't see his father's face in the darkness, though he could smell the whisky. He didn't move. "Josh!" his father hissed. He waited, nervous, nauseous. "Josh!" his father cried out. "And also—is Mr. Steven Spielberg in the audience? Steven! Ste-e-ve! I know you're here!" The crowd murmured angrily, and then the doors burst open and the manager, armed with three ushers, grabbed Kevin and dragged him out. "Hey wait," Josh shouted, stepping forward. He followed while they pushed Kevin into the

41

lobby and threw him onto the dusty red carpet. "I'll take care of him," said Josh to the manager. "Someone better, he's drunk. And I told him, no drinking in this movie house. And what a time for this to happen." It's never the right time, Josh thought. As he helped his father to his feet, he saw Steven Spielberg trying to slip through the lobby incognito, dragging the limp raptor behind him. "Great picture, huh?" said Steven Spielberg with a wink. "Did you hear that audience, they love it!"

"Can I have your autograph?" Josh said. "For my father?"

Kevin rose and staggered behind him.

"That's your father?"

"Yeah."

Spielberg paused, scratching his chin. "Forget it," he said, leaving the theater. "I don't sign for drunks, he'll forget about it in the morning."

Josh helped Kevin stay steady and led him out of the theater, watching as Steven Spielberg disappeared in the waning dusk, Kevin still pointing in disbelief. The last they saw of Spielberg before he turned the corner was him crumpling up the raptor, a pile of melted rubber, and dropping it in a trash can with a sign of relief. "Just don't forget Meryl Streep!" Kevin yelled.

Zoo Story

If you've ever seen *Cat People*, with Nastassja Kinski, you already know the first part of this story—how I became obsessed with big cats, the panthers and leopards at the zoo, how I battled my own best interests to become skilled in deceit. Mom and Dad had taught me right from wrong, but I dunno . . . I was always a contrary boy. But if you've seen *Cat People* you know that I crept out of my apartment every night that spring, to drive to a distant neighborhood out by the beach. That I parked my car blocks away and jumped the fence—

—landing with a jolt that made my legs grow numb, to creep toward the cages, night after night, sitting there in the wet grass motionless each night, staring at the cats.

In the spring darkness they moved restlessly behind the bars, their great sleek torsos shifting like fluid in fur. The cages smelled like meat and urine, and something I didn't identify but with which I identified, a primeval scent, maybe blood or animal sperm? Tell me if you know. You know so much, having seen the film—what did you, rent a video or something?

Anyhow in the dark I let my fantasies run wild. On the cold metal bars moonlight rained down, casting shadows across our bodies—mine and the panthers'. Wrapped in fur and sweat, they purred as they edged towards me, pausing to lick some salt out of a flat metal pan in the center of the cage. I wished the weather were warmer, I could have taken off my clothes—I felt such a powerful desire to do so, but no, it was pretty cool. At home I told my wife the grass stains on my pants were from touch football. That's an excuse I learned from watching TV detergent commercials. You always see these big macho hunks and from the waist down their tight, white, formfitting chinos are long stains of grass and dirt

rubbed in by hand, I suppose, by art directors of these TV projects. I wonder if the men are wearing the jeans while the dirt and grass get rubbed in and if they get sexually excited. That's the kind of thing I used to spend hours obsessing on.

I went to my family doctor, told him my desire to become a cat, he said he'd put me on Rogaine if my insurance would cover it. Or Prozac—or both. Otherwise he suggested that I do just what I've done—make countless trips to the Zoo, watch them in action, get my rocks off that way. Or buy a couple kittens from the SPCA, teach them to fellate me.

But one night I could stand it no longer. I rose awkwardly and took the few steps to the panthers' cage, and rubbed the front of my jeans up and around the cool bars. It felt good, like the bursts of light and stars you see when Cinderella's fairy godmother taps her wand. My zipper was buckling up like a railroad accident—like some boxcar had collapsed, sending its freight careening down some gully. I guess nighttime is the right time? Like George Jones used to sing. Was it George Jones? Or George *Michael*, har de har har. Behind the bars a sleeping panther cocked open one large yellow eye. Growled softly. A rustling breeze bent back the nape of its black fur, and I pushed my groin closer to the iron bar, then edged my kneecaps in to produce some friction, a little. I wasn't going for any one thing: I just wanted to feel a little different. I thought back in a flash—in a series of flashes—to the way I look without my clothes, I felt proud of my body, its stark glamor in dark places. I remember thinking that if someone was watching me— say there were paparazzi around—my thighs and legs were in A-1 shape and my hair was lightly scented with shampoo. I had nothing to be ashamed of. I'm a man. A man without a conscience.

What made that night different from all the other nights of my life? Yeah, there was a full moon above: you could pick out every detail of the cage and the thick paws of the cats, paws that moved and shone like heavy beefsteaks, their tread a whistle in the dark. Yeah, a pool of slimy water spread across the concrete floor, and the moon was in it, flattened out and golden. Yeah, and there was this long turkey neck down my leg, hot and puffed up, and it was my prick. "Bill Barbour," I said to myself, "this is your night to howl." Maybe there's a little part

in every guy that wouldn't mind getting clawed if approached in the right spirit. Or if hit up when he's feeling—down for other reasons. "Your night to howl," I repeated slowly, under my breath. And so saying I licked the cold bar of the cage and watched it steam before my eyes, before slightly crossed eyes, azure eyes the color of Icelandic seas and seamen.

But enough about me. When my mother was a girl, and pregnant nine months with me, a cat jumped into her lap and gave a ghastly howl, right at her face! Sent her into convulsions and labor. So I figure that's why I was there—it's not a sex compulsion, it's a gene or something. I wrapped my arms and legs around a tall cold iron bar and began to shimmy in, contracting and expanding the flexible muscles of my ribcage and hips, and feeling this icy heat at the base of my balls, flicker up bit by bit until my whole body was flooded with heat, a disaster for my suit—what a cleaning bill! But I felt for once alive in a primitive way, as I slithered between the bars to let myself be taken by the big cats. First they ripped off my jacket and pants as though they were so much cellophane. Then they stepped back as I swayed, trying to keep upright in my underwear, then they buffeted me with their snouts till I fell down among them, nude and helpless, a toy in the golden moonlight, my underwear a meal of shreds scattered like confetti around the cage perimeter. Next time you see kittens batting a catnip toy around, think of me on the cold concrete floor of the cage, pushed around, my neck snapping, their paws wet and warm on my chest, my legs, their claws retreating and contracting as they contrived to spread my thighs open to their hot rotten breaths.

* * * * * *

They cleared the cage and photographed my twisted torn body from all angles. Under luminol, the big cat's tongues and jowls glowed a ghostly green, and my wife fainted dead away, first fishing my cufflinks from the bed of flowers outside the cage. My butt was nothing but a leftover carved-up ham the day after Easter. My eyes, though, my eyes still in death must have been glittering,

gleaming, pleasure-mad. Ask them to show you the autopsy pictures of—my eyes, my glazed demented eyeballs. When I felt the panther's slick meat inside me my blue eyes must have narrowed a bit, then rolled up into their sockets until only the whites remain visible, and I had to come, and I had to die.

Chain of Fools

Again I approach the Church, St. Joseph's at Howard and Tenth, south of Market in San Francisco. It's a disconcerting structure, in late Mission style, but capped with two gold domed towers out of some Russian Orthodox dream. I'm following two uniformed cops, in the late afternoon this October, we're followed by the sun as we mount the steps to the big brass doors and enter into the darkness of the nave. I see the pastor, Filipino, short and shambling, approach us from the altar, where two nuns remain, arranging fall flowers around the vestibule. I fall back while the cops detain the priest. They're passing him a sheaf of legal papers regarding the closing of the church, which has been damaged beyond repair by the earthquake of '89. Anger crosses the priest's handsome face, then he shakes the hands of the two policemen; all shrug as if to say, *shit happens.* I glance up at the enormous crucifix where the image of Christ is sprawled from the ugly nails. His slender body, a rag floating over his dick. His face, white in the darkened upper reaches of the Church. His eyes closed, yet bulging with pain. Again I bend my knee and bow, the body's habitual response. Across my face and upper torso I trace the sign of the cross, the marks of this disputed passage. I'm dreaming again—again the dreaming self asserts its mastery of all of time, all of space.

Late in the 60's Mom and Dad enrolled me in a high school for boys, staffed by Franciscans. I was a scrawny, petulant kid with an exhibitionist streak that must have screamed trouble in every decibel known to God or man. My parents had tried to bring me up Catholic, but as I see myself today, I was really a pagan, with no God but experience, and no altar but my own confusing body. In

a shadowy antebellum building high on a hill above us, the monks rang bells, said office, ate meals in the refectory, drank cases of beer. In the halls of St. A——, bustling with boys, I felt like the narrator in Ed White's *Forgetting Elena*, marooned in a society I could hardly understand except by dumb imitation. In every room a crucifix transfixed me with shame: I felt deeply compromised by my own falsity. My self was a lie, a sham, next to the essentialism of Christ, He who managed to maintain not only a human life but a divine one too. He *was* God, the Second Person of the Trinity.

But I talked a good game, as any bright student can, and did my best to get out of my schoolwork, so I'd have more time to develop my homosexuality. I spent a year in French class doing independent study, reading *Gone with the Wind* in French, while the other students around me mumbled "*Je ne parle pas*" to an implacable friar. Presently I was able to convince the history teacher that reading *Gone with the Wind* in French should satisfy his requirements too. Then I could go home and confront my appalled parents by saying, "This is something I have to read for school."

Later on, when I was a senior and drunk all the time, a friend and I invented an opera, a collaboration between Flaubert and Debussy, set in outer space and ancient Rome, that we called *Fenestella*. George Grey and I flogged this opera through French class, music class, World Literature, etc. We recounted its storyline, acted out its parts, noted the influence of *Fenestella* on Stravinsky, Gide, etc, you name it. Our teachers slowly tired of Fenestella, but we never did. The heroine was an immortal bird—a kind of pigeon—sent by St. Valentine out into Jupiter to conquer space in the name of love—on the way to Jupiter she sings the immortal "Clair de Lune." I must have thought I too was some kind of immortal bird, like Fenestella, like Shelley's skylark. None of our teachers pointed out the unlikelihood of Flaubert (d. 1880) and Debussy (b. 1862) collaborating on anything elaborate. We had them quarrelling, reuniting, duelling, taking bows at La Scala, arguing about everything from *le mot juste* to the *Cathédrale Engloutée*. Nobody said a word, just gave us A's, praised us to the skies.

I had no respect for most of these dopes. In later life I was to pay the piper by dallying with several teens who had no respect for me.

Nothing's worse than that upturned, scornful face, that throws off youth's arrogance like laser rays. When I was 16 I had the world by the tail. But in another light the world had already made me what I was, a blind struggling creature like a mole, nosing through dirt to find its light and food.

In religion class Brother Padraic had us bring in pop records which we would play, then analyze like poetry. It was a conceit of the era, that rock was a kind of poetry and a way to reach kids. Other boys, I remember, brought in "poetic" records like "All Along the Watchtower," "At the Zoo," "Chimes of Freedom." The more daring played drug songs—"Sister Ray," "Eight Miles High," "Sunshine Superman," or the vaguely scandalous—"Let's Spend the Night Together." When it was my turn I brandished my favorite original cast album—*My Fair Lady*—and played "Wouldn't It be Loverly." Now, that's poetry, I would say expansively, mincing from one black tile to a red tile, then sideways to a white tile, arms stretched out appealingly. After the bell rang a tall man dressed in black stepped out of the shadows between lockers and said, "Have you considered psychological counselling?" I should have been mortified, but I shook my head like a friendly pup and, with purposeful tread, followed him to his office. Then the office got too small for his needs and he drove me to what I soon came to think of as *our place*, down by the river, down by the weeds and waterbirds.

Getting in and out of a VW bug in those long black robes must have been a bitch. Funny I didn't think of that till later. It happened in front of my eyes but I didn't really notice. I was too— oh, what's the word—ensorcelled. He—Brother Jim—wasn't exactly good-looking, but he had something that made up for any defect: he'd taken that precious vow of celibacy, though not, he confided, with his dick. First I felt for it through the robes, then found a deep slit pocket I was afraid to slip my hand into. Then he laughed and lifted the robe over his legs and over most of the steering wheel. And down by the gas pedal and the clutch he deposited these awful Bermuda shorts and evocative sandals. And

his underwear. His black robe made a vast tent, then, dark in the day, a tent I wanted to wrap myself up in and hide in forever, with only his two bent legs and his shadowy sex for company. So I sucked him and sucked him, Brother Jim.

"Why don't you turn around?" he asked. "Pull those pants all the way down, I like to see beautiful bodies." He made my knees wobble as he licked behind them. Wobble, like I couldn't stand up. On the wind, the scents of sand cherry and silverweed, the brackish river. The squawk of a gull. Scents that burned as they moved across my face, like incense. After a while he told me how lonely his life was, that only a few of the other monks were queers, there was no one to talk to. "You can talk to me," I told him, moved. Every semester he and the few other queer monks judged the new students like Paris awarding the golden apple. Some of us had the staggering big-lipped beauty that April's made from; some of us were rejected out-of-hand, and some of us, like me, seemed available. Then they waited till they felt like it, till they felt like trying one of us out.

He made me feel his . . . dilemma, would you call it? Boys, after all, are tricky because they change from week to week. You might fancy a fresh complexion: act right away, for in a month that spotless face will have grown spotted, or bearded, or dull. You might reject me because I have no basket, well, too bad, because by Christmas I'll be sporting these new genitals Santa brought me, big, bad and boisterous. This was Jim's dilemma—when you're waiting for a perfect boy life's tough. So they traded us, more or less. Always hoping to trade up, I guess. "Don't trade me," I pleaded with him. "Oh never," he said, tracing the nape of my neck absently, while on the other side of the windshield darkness fell on a grove filled with oaks and wild hawthorn. "Never, never, never."

I wanted to know their names—who was queer, which of them— I *had* to know. He wouldn't say. I named names. How about the flamboyant arts teacher who insisted on us wearing tights, even when playing Arthur Miller? No. None of the effeminate monks, he told me, were gay. "They just play at it," he sneered. How about the gruff math teacher, who had been the protegé of Alan Turing and John van Neumann? If you answered wrong in class he'd summon you to his

desk, bend you over his knee, and spank you. If you were especially dense you'd have to go to his disordered room in the evening and he'd penetrate you with an oily finger, sometimes two. "No," said Brother Jim, my new boyfriend. "Don't be absurd. None of those fellows are fags. You'd never guess unless I tell you." I told him I didn't really want to know, a lie, I told him I'd never done this with a man, a lie, I told him I would never tell another about the love that passed between us, a lie. And all these lies I paid for when June began and Jim got himself transferred to Virginia. But then another teacher stopped me in the hall. "Jim told me about your problem," he said, his glasses frosty, opaque. This was Brother Anselm. "He says you feel itchy round the groin area."

He's the one who took me to see *The Fantasticks* in Greenwich Village and bought me the record, "Try to Remember." If you're reading this, Anselm, try to remember that time in September when life was long and days were fucking mellow. As for you, Brother Jim, whatever happened to "never?" You said you'd "never" trade me, but when I turned 17 I was yesterday's papers. Thus I came to hate aging, to the point that even today I still pride myself on my "young attitude." Pathetic. I remember that our most famous alumnus was Billy Hayes, whose story was later made into a sensational film called *Midnight Express*. At that time he was mired in a Turkish prison for drug smuggling. We students had to raise funds for his legal defense, or for extra-legal terrorist acts designed to break him out. Students from *other* schools went door-to-door in elegant neighborhoods, selling chocolate bars to send their track teams to big meets, but we had to go around with jingling cans, asking for money for "The Billy Hayes Fund," and you know something, people gave! They didn't even want to know what it was, good thing too. Later when the film came out its vampy homoerotics gave me a chill. Later still, its leading man, Brad Davis, played *Querelle* in Fassbinder's film of the Genet novel. And even later still Davis died of AIDS and I conflated all these men into one unruly figure with a queer complaint against God.

Standing on the desert's edge, a man at the horizon, shaking a fist against an implacable empty sky.

At first I resented Jim and Anselm and the rest, their careless handling of this precious package, me. But after awhile I grew fond of them, even as they passed me around like a plate of canapes at a cocktail party. Anybody would have, especially a young person like myself who thought he was "different." I watch the E Channel and see all these parents of boys, parents who are suing Michael Jackson, and I want to tell them, your boys are saying two things, one out of each side of their mouth, or maybe three things, one of them being, "Let me go back to Neverland Ranch where at least I was *appreciated*."

Unlike Michael Jackson, the religious staff of St. A— wore ropes around their waists to remind themselves, and us, of the constant poverty of St. Francis of Assisi. One of them quoted St. Therese to me, to illustrate his humility: "I am the zero which, by itself, is of no value but put after a unit becomes useful." I pulled the rope from around his waist, teasing him. I took one home as a souvenir. These fat long ropes, wheaten color, thick as my penis and almost as sinuous. I believed in those ropes. I said to myself, why don't *you* become a monk, think of all the side benefits? I walked down to the grove of trees by the river's edge one April afternoon, thinking these grand thoughts of joining the seminary. Beneath my feet small pink flowers, a carpet of wood sorrel or wild hepatica, leading down to a marshy space tall with field horsetail, up to my waist. "God," I called out, "give me a sign I'm doing the right thing." I felt guilty that I had sinned in a car, guilty and stained, like a slide in a crime lab. I waited for His sign, but zilch. Above me a pair of laughing gulls, orange beaks, black heads, disappeared into the sun. *Is that my sign?* thought I, crestfallen. *How oblique.* But right around that time I began to realize that there was something stronger than a Franciscan brother.

Marijuana leads to heroin, they used to say. I don't know about that, but after awhile friars just don't cut it, you want something stronger, something that'll really *take you there*. You want a priest. Ever see *The Thorn Birds*, the way Rachel Ward longs for Richard Chamberlain? Or Preminger's *The Cardinal*, with Romy Schneider yearning for some other gay guy, it's a thrill to think, y'know, with a little luck, this man licking my cock could turn out to be the Prince of

the Whole Church, the Supreme Pontiff, in ten or fifteen years and right now, you can almost see his soul shining right through his thinning blond hair, already he's godly—Again the dreaming self rises above the squalid air of the black back room, the hush of the confessional, breaking free into a world of pleasure and Eros and hope, all I continue to pray for and more. Out in the snowy East of Long Island I bent over Frank O'Hara's grave and traced his words with my tongue, the words carved into his stone there: "Grace to be born and to live as variously as possible." Another lapsed Catholic trying to align the divine with the human.

And because I was so willful, I made spoiling priests a kind of game, like Sadie Thompson does in *Rain*. Under those robes of black, I would think, are the white limbs of strong men. I trailed one priest, Fr. Carney, from assignment to assignment. I was his youth liaison—encouraged to inform on my peers' drug habits, I had first to increase my own. You have to be a little hard, a little speedy, to become what we then called a "narc." He also got me to bring along other youths to retreats staged on isolated Long Island mother houses. When I graduated from St. A— I continued to traipse after Fr. Carney, like Marlene Dietrich slinging her heels over her shoulder to brave the desert at the end of *Morocco*, all for Gary Cooper's ass. "You don't have to call me Father Carney," he would say to me. "Call me Paul." I felt like king of the hill, top of the heap. Oh, Paul, I would say, why am I being treated so well? "Because you are who you are," he told me. "You are someone special. You are Kevin Killian."

I grew more and more spoiled, and he must have enjoyed my ripeness, up to a point; and then he left me, in this valley of tears. I remember standing in his room watching the cold green spectacle of Long Island Sound, leaves of yellow acacia tapping into the window, with this pair of black gym shorts pulled down just under my buttocks, and thinking to myself, I'll bring him back to me with my hot skin and my healthy boy type sweat. And him, Paul, slouched on his king-size bed, turned away from me, bored, extinguished, his breviary pulled next to him like a teddy bear. "There's a list on my desk," he said. "Some of them may be calling you."

So when I pulled up my pants I'd have this list to turn to, the names of other priests, *next!*—Like one of those chain letters, filled with the names of strangers, to whom you have to send five dollars each or Mother will go blind. "You're trading me too," I said, before the door hit me on the ass. Thump.

So the next guy called me, Father some Polish name, and he turned out to be—really into the Rosary. . . . Around this time I got to thinking that despite what they told me, I was not someone special after all.

These men were connoisseurs all right. They pulled out my cork and took turns sniffing it. Meanwhile the *sommelier* stood by, a smile in his eyes, attentive, alert. Disillusioned, dejected, I began to read the whims of these men not as isolated quirks, but as signs of a larger system, one in which pleasure, desire endlessly fulfilled, *jouissance,* are given more value. Within the Church's apparently ascetic structure, the pursuit of pleasure has been more or less internalized. By and large, the pursuit (of violence, danger, beauty) is the structure. I had to hand it to them! Under their black robes those long legs were born to *can-can*. Pleasure, in a suburbia that understood only growth and money. Aretha Franklin said it best, singing on the radio while I moped from man to man. "*Chain-chain-chain*," she chanted. "*Chain of fools.*"

I met Dorothy Day in a private home in Brooklyn, when Father Paul took me to meet her. She was seventy then, and had been a legend for forty years, both in and out of the Church, for her activism, her sanctity, her saltiness. I had read all about her in *Time* magazine. She sat on a huge sofa almost dwarfed by these big Mario Buatta-style throw pillows, gold and pink and red. Her hands were folded neatly in her lap, as though she were groggy. The way to get closer to Christ, she asserted, is through work. Father Paul argued mildly, what about the Golden Rule? Isn't love the answer? No, she responded sharply,— work, not love. Last night on TV I watched *The Trouble with Angels,* in which mischievous Hayley Mills raises holy hell at a Long Island girls' school, till she meets her match in imperious, suave Mother Superior Rosalind Russell. At the denouement she tells her plain girlfriend that she won't be going to Bryn Mawr or even back to England. She's decided to "stay on," become a nun, clip her own wings. I

remember again wavering on the brink, of becoming a priest, saying to myself, why don't you do the—*Hayley Mills thing?* Saying it to myself from the back row of this cobwebbed movie house in a poky town on the North Shore of Long Island, fingering the beer between my legs, all alone in the dark.

Now I'm all grown, Dorothy Day is dead, and when I open *Time* magazine I read about altar boys and seminarians suing priests. One quarter of all pedophile priests, they say, live in New Mexico. I have no interest in pursuing my "case" in a tribunal, but I'd like to view such a trial—maybe on Court TV? Or sit in the public gallery, next to John Waters, while my teachers take the stand and confess under pressure or Prozac. I'd get out a little sketchpad and charcoal and draw their faces, older now, confused and guilty and perhaps a little crazy. Then their accusers would come to the stand, confused, guilty, crazy, and I could draw in my own eyes into their various faces, into the faces of my pals and brothers.

Oh how I envied them their privilege, their unflappable ease, the queers of the church. If they were as lonely as they claimed, weren't there enough of them? If their love lives were dangerous, surely they would always be protected by the hierarchy that enfolded them. I remember one monk who had been sent away years before to a special retreat in Taos and he said, *I didn't want to have to come back and see any boys. But then I wanted to come back, it must have been to meet you, Kevin.* And I pictured this empty desert sky with nothing in it but one of Georgia O'Keeffe's cow skulls staring at me through time. My face broke into a smile and I said, "That is so sweet."

I broke with the Church over its policies on abortion, women's rights, gay rights, just like you did. Perhaps its hypocrisy angered you, but that's just human nature, no? What scared me was its monolithic structure. It's too big either to fight or hide within, like the disconcerting house of the Addams Family. I tried to talk to It, but It just sat there, a big unresponsive sack of white sugar. So good-bye. And yet I suppose I'm a far better Catholic now than

then. I dream of this god who took on the clothes of man and then stepped forward to strip them off at the moment of humiliation. This renunciation for a greater good remains with me an ideal of society and heaven. I try to get closer to Christ through work. I tried love for a long time but it only lengthened the distance between Him and me.

So I try to call the number of St. A— to see where the 20th high school reunion will be. So that's when I find out the school's now defunct, for the usual reasons: indifference, inflation, acedia. I continue to see the Church as the house of Eros, a place of pleasure and fun, and I continue to regard men in religious costume as possible sex partners, yearning to break free. Such was my training, my ritual life. I can't shake it off, I'm not a snake who can shed its skin. Every time I pass a crucifix I wonder, what if it had been me up there instead, could I have said, *Father, forgive them, for they know not what they do?* I don't think I'm so special, not any more. At the church here in San Francisco, I bow down and make the sign of the cross, the logo of the Church, an imprint deep within forces me to replicate this logo. Up, down, left, right, the hand that seeks, then pulls away frustrated. The hand tightens, becomes a fist, the fist is raised to the sky, on the desert's edge, angry and queer. Inside the Church burns incense, tricky and deep-penetrating, strong, perdurable, like the smells of sand cherry, silverweed, trillium.

Spread Eagle

When he invited me into his trailer I thought it was a big deal. He was so distant, so hard to get to know.

Outside the sky was turning over along the horizon, as though a rolling pin were flattening it out into gray clouds and brown mud. The tall pines that broke up the field around the trailer leaned into the wind. I kept hearing this whistling but not really. More like a body thing—the way you always can hear your brain clicking but most of the time who cares? It's there, you're walking around, so you're not paying attention to it.

His screen door was full of holes. Long notches in the thick denier of wire. "Bullet holes?" I said to him.

Like it was a joke.

He hummed that music from "Jaws" and said *moths. Man-eating moths.* And he let me in, over my shoulder he was staring out at the pines as though all his enemies were amassing behind them. Even for a guy like me his behavior was somewhat spooky.

"In your honor I'm playing this special song," he said after awhile. "What is it?" said I. He turned his dark eyes to me and they widened into a gape. "Jethro Tull, *Aqualung*," said he, with this reverence that didn't fit him. "Oh that's great," I said swallowing fast.

I forget what he was wearing but it was red and black like the kit of a hunter. And warm. Inside the trailer it was cold, and his little speakers were going apeshit with this hoarse old man and this thudding bass. But I was so pleased to be there I could have listened to it all night. Like Audrey Hepburn in *My Fair Lady* jumping up and down in those featherbeds and the maids trying to restrain her. I guess I'm more like Audrey than I want to think. It's not that I don't like her it's just that she's such a femme.

My mother always used to tell me *you will never get anywhere if you always act like Audrey Hepburn.*

What does she know about getting anywhere, she's dead! Farthest she ever got was the cemetery! I sat down on this tiny built-in couch with a table built into it that came up over my knees like a comforter. A lamp trained down. Across the dirty surface of the table, a variety of powders lay arranged in piles and stripes. A large knife, its handle a heavy chunk of wood, rested next to a rolled up copy of *Fortune* magazine. Then I unrolled it and saw, no, it was *Soldier of Fortune* magazine. Silly me.

Silly me to make that mistake about this one man.

He smelled like a mixture of hair tonic and sewage and velvet. Ever since he came to town I wanted to get to know him. I guess he'd been in jail several times. We sniffed some of that coke. Then he says it wasn't really coke, but some other harder thing. I don't know what.

Our town's a dull one and a dark stranger makes all the difference. It's not that we don't have our share of problems, but we don't have much danger. The way I make my living is my own mail order business—I buy and sell rare documents and autographs. Guaranteed authentic to the trade. A lot of my business comes from the ads I insert into Hollywood magazines of all descriptions. Pretty safe.

"Want a drink?" he said.

"I'd like a Ramos fizz," I said. It was chilly and my sweater was starting to feel too thin; and a Ramos fizz can warm you up on a cold October night better than anything.

I should have known this was one outpost of civilization where I wouldn't get me Ramos. Instead he plopped down this bottle of Irish whiskey onto the counter and got a glass from the sink. It looked dirty, the glass, but hell, I was in this for the adventure of the thing. The black hair on his forearms. Ever since Gary Parker Radley came to town his dark spectral stare and his muscle-bound body had inspired me to new lows of abjection. Still I don't think I'd have gotten to first base if I hadn't indicated an interest in joining his cult.

Above the bed he had nailed this piece of cloth, is it cloth? I said to myself, looked like a face. Looked like a face sewn out of a brown loose weave, flattened out like a pine against the north wind, so that the

eye holes and the nostrils and the mouth were loose flaps of cicatrix that dangled here, jutted there. Below the face part was a throat and a pair of shoulders, then a chest as far down as the nipples which looked like dried up old acorns from Mother Nature's inexhaustible well, all strung together in this loose brown cloth weave, not very appetizing.

You couldn't tell what it was. It was the kind of thing your eyes just glaze over and miss. Especially when you're horny or getting so. Thus it was only after we fucked that Radley told me it was human skin from this guy he'd offed in Bakersfield.

"Right," I said. HA HA HA HA like the cops say in LA when they destroy this Negro.

Actually when he said "offed" I didn't know that meant "killed." The particular way Radley fucks it's like this new process for me. That itself might have been "offing" for all I know: although I'm intimate with Hollywood dish there's a lot of the seamy side of life I've been spared. I mean here's this megadeath metal monster trying to poke me a new asshole. Later he said offing means killing. Casually, like Audrey in *Breakfast at Tiffany's* when she lets her cat, "Cat," lick at her Martini. And that this souvenir of death was supposed to be one of the hallmarks *of his new cult*. Naturally I'm curious.

Bakersfield of all places! Where Marilyn Monroe was born. It's about an hour's ride from here if your car's got any juice at all. Radley knelt down, eyes closed, and I standing before him took my hard dick in my hands and touched it to his eyelid, then to his other eyelid, anointing them both with my pre-cum so they shone and glistened in the cold moonlight. His mouth was open like he wanted to take me all in with that deep throat thing he must have learned in state prison or boys town. His eyelids wet, and the light and dark falling on his nose and chin.

"Is it gonna be like—" oh, I couldn't think of his name—"like the cult of Mr. Bret Easton ELLIS!" He poked my ribs so it hurt. Then he told me about Blue Oyster Cult and how they worshipped Satan and cut up roosters and smeared their entrails all over Long Island and that's how they got a record contract and

became stars. I don't know, back in the 70's or some time. I lay on my back, sort of, sort of on one side and he guided in his big cock and my entrails swelled around it, meanwhile he explained about his vision and his trailer hitch and this other boy he used to know. Well, hon, I *know* stars. And Blue Oyster Cult I never heard of. I can forge Audrey Hepburn's signature 100 different ways, all of them accurate, like when Audrey was having her period she made her letter R's a little giggly, like they must have given her happy pills up the wazoo and *Blue fucking Oyster Cult is not a star!*

You can take that from the horse's mouth. Anyhow I live in this dull town and Gary Parker Radley came to us from out of the night, in his silver trailer that rolled up out of nowhere. The first few days he kept to himself and then townspeople reported they'd seen him buying some foodstuffs, mayo and ham and V-8, one afternoon totally pale and muscle-bound at the 7–11. My ears pricked up. "Horsemeat." So I stake him out. And I watch the trailer from beyond the clump of Christmas pine till I get to see him through his screen door once, his head cocked into his elbow looking sideways, glum, into the sun. "Is he a vampire!" say I, excited. I'm wearing my oversized Givenchy shades like Audrey had at the beginning of *Charade* with Cary Grant. I feel like a spy trying to get forbidden data, the cold blades of red grass frosty at my ankles. The screen door moves sharply and I see my man's white legs and his muscles are not to be believed. He's wearing this pair of orange undershorts I could lick off of him like a dreamsicle.

He's far from being a bad-looking son of a bitch.

Somehow I'll get to know him thought I. *There's a click in the universe when two worlds collide.*

Before I came to his trailer door I sat in my office writing letters from Audrey. "Mr. Cukor introduced me to a charming man," I wrote, all in the up-and-down bumpy hand characteristic of Audrey on vacation in Spain, "whose Marine uniform looked snappy outside the corrida. If I weren't happily married to Mel it might have been an occasion of sin, Eileen." I had invented a bubbly girlfriend for Audrey who always seems so forlorn and demure. These letters, aged with soot and metal oil and scented with *Je Voudrais*, will sell for $$$ to a besotted queen in San Antonio. Then I went to the trailer with my heart on my

sleeve, I guess. Just asking for an opportunity to turn myself into San Quentin quail.

"You come here just to get laid?" he said.

He'd been quiet a long time, looking up at his face mask and the rest of the mounted scaly skin.

"Ah, no," I told him. "I wanted to get to know you."

"As a person," he supplied.

"Well, in a way," said I. And finally I gave in. "Do you ever go out and do stuff? Like—get into Satan?"

He punched a fist into his open palm. "That's *not* it, it's not about Satan or *any* of that other high school bullshit, grow up, will ya?" When he got angry the tiny ridge of fat above his breast muscles quivered in a white long line. All of a sudden, up on his feet, his balls bouncing. He slapped my butt and told me to lie spread-eagle. Not easy in a trailer for Christ sake, this trailer has got to go. But somehow I accomplish this by cheating a little, like my elbows bend up. I keep thinking I'm hearing this whistling? This strange *Moon River* sound, the wind or some other force of nature. I'm like totally transfixed by it. Reminds me of this joke—this guy goes into this paper goods store and asks the girl, "Pardon me, but do you keep stationery?"

"Yes," she says, "at least right up until the very last minute."

Corpse

(with Stephen Beachy)

On Halloween, the trees are whispering these low moans into the sides of the big brick house as Ralph rings the doorbell without a response.

"That's odd," thinks the boy. "I swear I saw somebody moving around upstairs. I'm reminded of Nintendo video games in which secret doors open into treasure rooms guarded by two-headed monster sheiks." But he doesn't really care about that, he just wants to get to the bathroom, and quickly, before he explodes. There's a lot of grief in this old house, or so he feels. Maybe he's imagining it, or is the door ahead of him really leading into some bizarre otherworld akin to the underworld the ancient Maya believed they could access by perforating tongues—you know, the kind that interlock no matter how tightly you try to control them. Ralph looks down shyly and tells his host, "You make my neck burn." Indeed, every time he sees Gary it's like walking into a guillotine.

Regardless, he gives him a peck on each cheek. A foul odor is emanating from Gary tonight, subtle, he can't quite put his finger on what it reminds him of. A small animal perhaps. Like a cat or mole. "Have you met my sister?" Gary says coolly, introducing a young blonde woman who looks nothing like him. "I don't think we've met," responds Kim unexpectedly. "Nice to meet you, but what are you dressed as?"

"Lizzie Borden, isn't it obvious? One of the few famous female serial killers. Yes, Genet's *Maids*, of course, but isn't one murderess enough?" Instead of replying, Gary rushes to the barrel of water standing next to the Philippe Starcke sofa bed. On its flat, calm surface bob four of the reddest, roundest apples Ralph has ever seen. He's hypnotized by their curves, and more than a little

unnerved. They're like Cézannes, but in 3-D, he thinks, swallowing hard. Behind him Kim laughs the rich laugh of the utterly possessed.

"One murderess is plenty," she says, "as long as she's got class." Ralph tries to remember how he got here. Blank spaces. "And I do," Kim says. "Do you like my shepherdess outfit? Got it at Saks Fifth Avenue."

"Gary," Ralph says, pulling his "boyfriend" to one side. "How can I concentrate when you've got your sister here glaring at me like the Queen of Hearts? I thought this was going to be just you and me."

"Sorry, lover boy," says Gary, flicking a razor in the water. "This is a family affair. I had to prepare myself adequately with a three-day debauch of hard drugs and sadomasochistic sex." He sneers. "Ooh," says Kim. "You scare me, little brother, you are so decadent. Just like when Dad and Elle hired that gardener guy. And you had to show him your little bulbs."

Ralph's neck is really burning now, as though a vampire's kiss had turned his veins to fire. More and more he longs for the ambiguous cave of Gary's bedroom, where all the walls are dark as liquid mud, as close as summer. "Why's it so hot in here?"

The room seems to be shrinking. Why are all these slimy eels and jellyfish hanging from the walls? Ralph giving Gary the most, there's no other word, *sinister* look. "Welcome," says Kim, as she throws open the basement door. "Down there you'll find ghosts and spooks to your hearts' content, all you ever wanted. I'm going out to hear a band."

"Good riddance," Ralph mumbles. One toe touches the top step of the cellar stairs. It's completely black down here. Then a grinning demon pops out of a niche on the stairs and he jumps, stumbling down the long flight to pitch blackness. In his heart he feels the terror of not knowing where you are or how long it'll be until you're found again.

"I loathe you," Kim continues. "I've always loathed you." A scream echoes repetitively through the darkening labyrinth of narrow spaces. A woman leaps onto Gary's neck. "Elle!" he gasps.

"My own mother!"

Still unconscious, Ralph misses all this, only hears about it later, in November, on the phone with Kim. "He was sure—we all were sure—that Elle was dead," Kim says. "She had the kind of personality you'd like to take a knife to."

I was so close to him we felt like twins, Ralph thinks, *or so I thought*. "But you didn't know about Elle." Elle's fine porcelain hands grip tightly around her boy's red neck. His eyes are bulging, bright balls of snow and wine. He's hoping that this is a dream (ha!) or a joke, like some dark, gnostic fraternity initiation, but when the eyeballs pop right out, like in some cheap slasher flick, he knows it's real, all too real.

Meanwhile Kim's smoking a little crack on the hood of a Mercedes outside the disco. Those guys, she thinks, it's like—everything in the world has to be their big psycho-drama. She touches her skirt, pats it back over the guy's scuzzy head. Hope they rot in Hell, those two. Oh, she sighs as the smoke anoints her brain, it's real or whatnot . . . it's real for sure.

A Love Like That

I press a ten dollar bill into the cabbie's palm. "Thank you, boy." He nods at me, then shuffles off backwards, into the shadows. I'm dangerous tonight; even service workers know it.

Feels like it's about to rain, in the last hour the temperature must have dropped thirty-five degrees. This old hotel's not the best in town, but it used to be, and I like its faded elegance, its fuck you impudence—it's like some old drag queen, bedraggled and weather-beaten, with a few good stories and a scrapbook bound in dusty alligator. Into the lobby I pass, with my one bag. High ceilings, walls covered in brownish red velveteen, dirty along the top, and a few floral centerpieces on the marble-topped tables that litter my progress. I look pretty good, I think, in a jet black dress, but I'm nervous. If anyone realizes I'm a man—I'm sunk.

"Yes, you can," I say when they ask me if they can help me. One geezer with saggy neck and liver spots on his ordinary face. One younger man, almost a boy, fresh, clean, decent. They're both white, and I wonder if the Hawkins Hotel hasn't heard you can hire desk people of any race nowadays. It's a political thing with me. I always notice. Always. The oldster kind of backs off and lets the boy do the talking. Maybe it's Darwinism in action, as if to say, *Me old now, you have fun.* I don't mind because the young one's my cup of tea. He's blond with a rough cowlick he must have moussed heavily to make it keep its place. I find that appealing. I like that kind of forcefulness in a man. I tell him I have a reservation and need help with my bag.

He trails me into the second elevator, led by my perfume. I'm small, tall as a woman. Heels are such a temptation, but it's walking the walk that gets so many of us spotted. I don't intend to advertise my gender. I'm this gender-bent queen with a mission,

I'm dangerous tonight. But I guess I'm all right. "New in town?"

"Yes," I said. "With all new money. Can you bring up a bottle of Johnny Black, and maybe some Tab?" This, at my door. I don't want him in just yet. *Soon*: not just yet. I want to give myself five minutes alone, inside the room. I wonder if Tab's hard to find in this part of the city. At one end of the hall a high window reveals a night sky swept by lightning—very Goya. Silvery night with pink neon streaks in it. You can see the wind, wild, as it blows holes through the rain. I'm shivering a little, not just from the cold, but I always shiver when I've just shaved every hair off my body. From my head to my toes. My skin's soft as silk, except for the goosebumps my mission keep raising on me.

Goosebumps—who gave them that name?—are so queer, no? Remember in *The Exorcist* when they rip open Linda Blair's blouse and in raised letters on her little chest they see the words HELP ME? The boy gives a nod, and wipes his palms briskly down the front of his black broadcloth pants. Another gender-tied gesture he won't catch me in. Not by a long shot. I kiss him on the mouth. His name is Jeff.

My "name" is Kelly. A name most men don't find threatening. A name that says, *hi, I'm a nitwit, fuck me over I won't even notice*. My gun's in my purse, a gun as big as my hand. Oh, I've got a little spot on one nail where the polish dried too fast. Under the lamplight by the bed I see it good, and it riles me. You spend good money for a good manicure and still, you got to watch them every damn moment.

The room's okay—it's big. The bed's king size, as specified; the carpet's nothing to write home about. The flowers are fresh—white, white hyacinths with just a trace of purple down the center of each petal—lovely. I brought a little Tab with me so I pop open a can while I wait. I readjust my small firm breasts—they're very good most of the time, like two obedient pets. Tab is so delicious, kind of a metallic taste. I often wonder if a gun, inserted in one's mouth, would have a similar taste, but I bet a gun's more oily-tasting, whereas Tab is crisp and clean. Bracing. I'm fretting over my makeup in the bathroom mirror when the phone rings. "Miss FitzGerald? It's Jeff."

"Jeff?" I say, as though it were some foreign word.

"The bellboy. Listen, I been all over, I can't find any Tab. Will Diet Coke do? I've got your Johnny Walker."

"Are you married, Jeff?" In the mirror I see my lips saying his name. "Jeff" with a little question mark at the end of it. I look fine. I'm just a little chilly. My cock and my balls, tucked up into this little garmentiere, must look like a pretzel by now, you know, those New York kind they sell from little steel carts under umbrellas. Big puffy pretzels I used to love when I was a boy. But now I'm a man. But now I'm a "woman."

"I'm single, Miss FitzGerald."

"Oh good," I say. "Diet Coke will do," I add. "Don't go to any trouble. Not on my account." He's standing in the rain at some pay phone, out in this passionate torrent for my sake. I hang up thinking, *he makes me feel good.* I think of his wide smile, his big lips, his clever little ears that spring up like Ross Perot's—okay, not like Ross Perot's. I think of all his features—soaked now, soaked wet for me.

I brush my hair, standing in front of the bureau. Knock-knock, conspiratorial. Quiet, because it's after midnight and a few other guests are sleeping on this floor. The Hawkins Hotel, built in the 1920s, manages to attract a number of well-heeled visitors to our city. It's fading, though. They still offer 24-hour room service, unlike many of the newer streamlined hotels, but often enough the kitchen will tell you, I'm sorry, nothing hot right now. Or, it's after hours, sorry, no more liquor. No matter how I shriek and beg: sorry, so sorry. He has the key, but he's polite and knocks. That's nice: I like that. There's a lot about him I like. When we're comfortable together, I try to find out when his shift is over, and he grins and says it is over. "That's why I took my shoes off."

"You must like me," I say, "a bit. Look at you, you're soaking wet. Make yourself a drink, Jeff."

"What I'd like to do, if you don't mind, is grab a shower, change out of this monkey suit." He'll be right back, he has street clothes in his locker in the basement of the hotel. Is that okay?

"Just so long as you return," I tell him, lingering at the door. I wiggle my fingers as he moves further down the hall, silhouetted in the high window at the end of the passage. No lightning now, only the pink neon slapping the rain and the night—and him

framed in it till the elevator comes. He looks at me and gives me one of those thumbs up signs. I can't read the expression on his face, but with men you don't need faces to read. They manifest themselves in dozens of other ways. And Jeff's shadow is out there jumping up and down, slightly, on his heels, his head cocked to watch the elevator lights. His fingers are plucking the wet broadcloth away from his thighs. His knees are slightly bent, his hands chilly.

I'll warm them up. The elevator comes, I pull open the drawer of the nightstand for the phone book. Justice of the Peace. And also, let me have a car sent round. I select "Presto Limo"—wouldn't you? It sounds so . . . speedy, and I'm in a hurry. Again I look at my face in the mirror, my lips parted slightly. I have fine white teeth, not too large. There's a space between my lips where the shadows reveal this mysterious chiaroscuro of promise. It's like I'm saying "yes" constantly, without having to stain the air with a single syllable between us. Who's "us"? Me and any man who crosses my line of fire.

First it was Daddy. When we're grown up, in charge of our lives, it's hard to look back honestly enough to admit how awful it was for us as kids. Even I was unsure—an unsure sissy Daddy despised. Fuck him, I say now, but then I trembled at his every displeasure. I had my dog, Peter, to comfort me, make me look butch. Otherwise there I was, reading every Janet Dailey novel I could get hold of, crossing my legs above the knee, and sure enough, Daddy tripping on my patent leather and swearing. And I didn't know what to do. I was about eight or nine—so was Peter. I went to the kitchen and found this knife and said to Peter, *well now it's time to give you a manicure like the poodles on TV.* He said, *I'm not a poodle, I'm a Westie!* But actually I stabbed him to death with the knife: that "larned" Daddy all right! The big lesson, that comes to all men eventually—Don't fuck with a queen. I *had* loved Peter but he, like Iphigenia, had to die to insure fair weather for Troy. When I buried him it was with a poignant smile of grief and regret, and with a miniature black parasol trimmed in jet. And real tears! I moved my mouth and said some prayers for him, and for my own soul, while from behind a bayberry bush Daddy looked on, his eyes two small squares of jumpy diamond—cufflinks of the damned. I say now: fuck him. And my mouth parted slightly, prayers coming out, me this little

she-boy in rusty mourning. And now I'm a man.

And a "woman." Again his polite knocking. "It's me—Jeff!"

"'Jeff?'" I repeat, like a misheard excuse.

"Jesus, the bellboy." I let him in, him still shaking from the ball of one heel to the other, not dripping so much but still soaked through. He shuts himself up in the bathroom—almost. Leaves the door open a crack as though I might be interested in his bare skin, which I see, sectional stripe, in the yellow light pouring from the bathroom ceiling. Not the skin of a child, but toughened slightly, yet still parts remain tender, swollen. The noise of the shower covers my phone conversation. I'm arranging our wedding. Me and him. A few drinks later I show him the money I'm prepared to offer. He's a single guy on the make. I tell him about my problem. He's lounged on the bed, a big white hotel towel pulled around his middle. He's slim, in shape. Must do Jane Fonda's Step-er-cise, I figure. He raises his glass to his lips and stops there, pondering the thousand dollar bills spread out around him like a laurel wreath.

"What is this?" he says to himself.

"No one will know," I swear. A small tattoo of a snake decorates the convex sheen under his left nipple. Navy? Jailhouse? It's blue and green and black, a dot of crimson for a tongue. He's got my pulses racing waiting for his reply. I don't like the way that makes me feel, so I console myself thinking about the valium heaped in his drink. And the three drinks he's downed already. *It's okay, my girl—my dear misunderstood darling.* "I like your tattoo," I whisper.

"Mmmm?" I help him into his "street clothes," one leg at a time, fix his buttons, comb his hair, like you might help a toddler get himself dressed.

His cowlick's sticking up. His hair had a mind of its own, which is more than you can say for him, the person, the human being. All my drugs have made him weak: he's like the economy, slipping and sliding and toppling over at my feet. This would be a dilemma if I didn't have a driver. A big strong hulk from somewhere like Estonia, in a muscle shirt and a steel-tipped cap that

says "Presto."

"I'm Kelly FitzGerald," I say grandly, stepping over the body to shake his hand. "You must be from Presto."

He nods.

"Okay, Presto, here's the deal. . . ."

Presto grunts and straddles Jeff, lifts him over one shoulder with ease. All those years lifting sacks of coal in a mining cooperative in Liszk have paid off. "In car?" he says. His big burly hand planted square in the middle of Jeff's ass. Hope it doesn't leave a brand there. Hope it leaves a brand there.

I'm a girl of two minds, as you can see. We make a funny caravan bumping down the service stairs. I keep a sprig of hyacinth pinned to my fur, close to my face, for good luck. Also it makes your eyes bigger: you'll often see photos of the glamorous Hollywood stars, flowers near their eyes. Sophia Loren. Carole Lombard. Ginger Rogers. Now I sound like "Vogue," so let me move on. Into the car—down the almost-empty streets of this city, buildings rushing past me, corners, streetlamps, civic monuments bare and stark, the rain abating.

We leave the city to cross the state line at an obscure footpath. Jeff stirs and I pat his knee absently.

I don't really want to do this, I'm realizing. All this sordid, frenzied hoopla. It's not me, not really.

I would have preferred to do it another way. The presence of the gun in my bag alarms me. It's like a time bomb, just ticking till it goes off. Wasn't it Chekhov who said, if you bring a gun onstage in Act One, it has to go off in Act Three? *One* of those gloomy, cheerful Russian saints. "Chili Peppers okay?" says Presto, leaning back, before he shoves a tape in its machine. I don't know what he's talking about, but when I hear the music, sour thoughts cloud my mentality. Should have brought some Petula Clark or some Sondheim, but that's life, isn't it—one regret after another, one mistimed fuckup after the next—then you're forty—then fifty—and who'll be there to say *it wasn't your fault, relax, forgive yourself?*

Jeff stirs and smiles in my arms. He'll be awake by the time we get there. Thirty miles over the stateline a little thatched cottage bobs before the unsteady limo headlights. I know instantly this is the place.

There's a light burning on either side of the front door. They're waiting for us, even though it's close to two.

An elderly woman in a thick quilted robe pokes her head out as we approach. "Finally!" she snorts. I have to remind myself, be gracious. Maybe a little will rub off on her. Not likely but you never know. I press some money into her hand and explain how my fiancé's tired from "a long flight." As though he were a pilot instead of a bellhop, tee hee. "Thank you for seeing us at this late hour, Mrs. Wickwire. As I explained on the phone, we only have a tiny little window of wedding opportunity."

She's used to lies, I suppose, for she just nods and says she'll fetch the judge. I notice a Hammond organ in the parlor. Hammond—hallmark of quality. Yeah, if you're from the bourgeois class like these two bores.

Mrs. Wickwire exhibits a fabulous collection of blown glass and cloisonné clowns. I wonder if she hadn't been born in a trunk, like Vicki Lester. No clown is too ugly for her, or too garish, so long as it's turquoise or pink or some shell-like shade. Gathered on the bookcases and fun tables, the glass clowns are grouped in familial postures. "I spend two weeks a year at bazaars and flea markets all over the State," she confides.

"That's not very much time," I say, throwing my hands into the air. "Think of how many you could buy if you shopped, say, eight months a year!"

"I go for quality," she say. "And now, with the Home Shopping Network, and QVC, one hardly has to leave one's armchair."

"True, true."

Like a child Jeff's asking, *Kelly? Kelly? Where are we?* The Judge boisters in, robes flapping. "Is this the boy?" says the Judge, slapping his hands together. "He looks drunk to me." *Oh well,* is his tone. *Drunk or sober don't make no difference here!* He's the one of those old men who's seen everything. "Okay, haul him up," says Judge to Presto. "Martha, places please." Martha scurries over to the Hammond and shakes her fingers as if to dry her nails. Then she contorts both hands and plunges them down onto the keys as

though trying to smash through to the pedals.

Oh, mercy. I knew I should have brought my Sondheim CDs. Still I make a striking bride, my head thrown back, my black hair cascading past my shoulders. A bouquet of white hyacinths, violet-striped, white, green and violet, clenched with my little bag, which I open, to pat my gun. I've thought a dozen times about how to shoot this scene. I know this one writer who told me, "If you've got five people in a room, you've got at least two too many." I sway from heel to heel, counting heads. The Judge drones on about his dearly beloved—not that I buy his party line. Martha's gray, rude head's bent over her Mendelssohn. Presto and Jeff, like Igor and Adonis. Then there's me. Five. That settles it. "I now pronounce you man and wife," says the Judge triumphantly, and I reach for the gun. Then I decide, no, forensics will crucify me, I go for the knife instead. "You may now kiss your bride." "You are so full of shit," I snarl, and with one jerk I push the knife into his gut. He groans and falls back. Presto's next. "I hate the Red Hot Chili Peppers," I tell him. The blade's red and wet as it careens across his big lumpen throat. Gug. Martha keeps playing, like she doesn't know what's up, and not until I knock around a few of her precious clowns does she snap to. Too late, Martha Wickwire. Too late for you and your whole bourgeois world! "Kelly," Jeff begs. I don't like to turn on him, but I have to. It's in my blood. "You and all you straight white males can kiss my drag ass," I tell him, but one half of my face is crumpled up with the effort to smile, still to "make nice" like we're taught in society. I touch his hand. I see the drops of blood on my lovely fresh flowers. It's silent now without that Hammond organ. I'm touching his hand, feeling the warmth and the life of him ooze out onto the hardwood floor. This viscous mess all that's left of my proud slim bellman. Like a coating of diamond dust, ground glass litters the floor and the bodies. Ground bits of glass that used to be clowns. "Isn't it rich?" I sing to myself. "Isn't it—queer?" In a beautiful alto. "I thought you'd want what I wanted—Sorry, my dear." See, Stephen Sondheim hits the right note on any occasion. "But where are the clowns? There ought to be clowns—Send in the clowns!"

Then I pick at Presto's pockets for the key and try to retrace my steps. Like, for example, I know that state line was thirty miles back.

That much I remember. I'm all choked up, but I manage to start the big motor. Then I'm on my way. Under cover of darkness I hike up my skirt and rip the constricting bag from my crotch. Between my legs my visible signs tumble out like the dice in *Guys and Dolls*. Oh, shit, I think, does that ever feel better.

—after William Castle's *Homicidal*

Brother and Sister

I wonder if it's true what Nietzsche said, that what's done in the name of love takes place beyond good and evil? Now that I'm grown I do my wondering on my back, thinking often of my mother. One night she dashed into my room and seemed to ooze into my bed in a flood of geranium perfume. "I'm going out tonight," she said, excited. Her first date in almost two years. "Imagine, Winston—And he's from Turkey!"

"The country where there are all the camels?" I asked, half-asleep. My mother's fur jacket tickled my bare chest. "I don't know about camels," she giggled. "But Mahmoud has got big muscles and the biggest hat you've ever seen! Come to the window, Winston, look out on the street. That's Moody waiting for me, sitting on the hood of that Chrysler." In foot pajamas I padded to the attic window and sure enough, dim as gravy, under the streetlight was a huge hat that bottomed out into the tiny figure of a muscular midget. Due to foreshortening he looked so small I thought, Mom might as well go out on dates with me. "He's not really a midget," she explained. At the doorway she turned once more, one last time, to blow me a kiss and then she was gone, the lights dimmed because she was gone. Alone in the dark I fretted for awhile, then took out my trusty companion *The Brothers Grimm*.

My sister, Eve, came in to help me read. After my mother married Mahmoud Clinton, then died, he kept us around to do his chores. He wore a faded cotton T-shirt and a pair of golf pants most of the time. Those pants started out as red, then I washed the pants in too hot water so that the color ran all over several contiguous items of underwear. By mistake, but I got it anyway, but good. My sister stood up to him and his wife, but I was their ser-

vant till Eve took me away and we ran down the streets with her suitcase and her radio. I was all out of breath, being a weak piece of shit.

Eve found a safe place for us, cool and dark like a glade of maples. Still I used to sit around the apartment and think everyone was after me. Being weak, I attracted bullies, bullies and snobs, men who thought that because I was puny they could prove points bouncing my head against a wall like a handball. My sister Eve would tell me, "I'm afraid for you. You're in a lot of pain. Psychic pain."

She'd been through a lot herself but she was stronger than I. She and I lived poor on Minna Street, the factory district of San Francisco. I got a job at Rainbow Foods, helping people select natural fiber and grain for re-sale. Eve was more successful, working as a model at Macy's and other fine stores. Everywhere we went, though, the shadow of Clinton and his wife hovered like nitrogen, like some poison a baby might lick off a wall then turn blue and die from.

Our stepfather was old and hard, like a tin can the goat's been licking the peel off of. Clinton was his name, just like our president. He'd call up at all hours demanding I come back and be his slave. He sent boys over to intimidate me with threats and violence. I got so scared I couldn't leave the house. Eve wore carnations like my mother.

We watched this Russ Meyer movie, *The Seven Minutes*, based on the famous novel by Irving Wallace. The famous lovers say to each other, "When we are apart, we are so weak; but when we are together, we are so strong." I told Eve, "Same here, except you're strong even when you're apart."

"I don't mind if you're not some Schwartzenegger goofus," she said. "Just stay off the drugs." I was to remember her words much later.

King Arthur
Across the alley lived this tall man with blond hair, always came dressed in leather—I figured him for some kind of rocket scientist. His eyes were green, like the stems and leaves of tulips, and he made friends with everyone easily. His name was Arthur, the king of Minna Street. He had this Arthurian complex. I grew to love him right away, because if any bullies came by, he would have his goons chase them out of the

street.

In the spring Eve and I went on a picnic in Muir Woods—tuna fish, mayonnaise, hot chicken wings, and watercress sandwiches because that's what I liked—she brought her transistor and played pop music, and after awhile my ears started to hurt and I crawled into the woods like a dog with my Denton Welch; delicious sunlight struck down onto the forest floor and overhead you could see a blue sky between the tree-tops. In a glade of silver birch trees the ground was covered in all directions with yellow celandines. Snowdrops dripped from the stream. I saw a dozen crocuses growing round the foot of a redwood—gold and purple and white. Then I fell asleep. The trees began to come fully alive, The larches and birches were covered with green, the laburnums with gold. Soon the beech trees had put forth their delicate, transparent leaves. I was dreaming of a handsome man who would come rescue me. "He will come," said the dancing trees. "Wait and see," they whistled.

On the bus back to the city my face started scratching, and Eve exclaimed. Oh boyfriend, she said, I think you got poison sumac. She rubbed aloe vera gel from a tube into my face, but the swelling continued. I started to cry and she said, let's just get you to the hospital—and Arthur met us at the terminal and took us to General. The doctors gave Eve a prescription and in the car Arthur grabbed it and went hmmm. This is for steroids, he said, and he started to laugh a little. What's so funny, King Arthur, said Eve.

Oh, I don't know—So I took steroid pills for a few days or so, sitting in my room with my face big, round, like a pumpkin, covered with white blotches from dry calamine and dry skin, while Eve went to work, glamorous in Norma Kamali.

I was watching *Santa Barbara*, kind of happy, when the door cracked open as if split by a hatchet. Clinton's eyes had the gray yellow look you find on the back of postage stamps on the instant before you apply your tongue. "I'm indispensable," he said with the air of one stating a fact. "I'll wait for your sister to come home. Why don't you take my keys and run down to the store real fast, buy me a box of Fig Newtons?"

"Gee, can I?" said I.

"Sure, but you got a license?"

My heart fell and I shook my head once or twice, with the loose floppy motion of a spaniel's ears.

"Then forget it, kid." Clinton's face squinched up in glee. "What's a matter wid you, can't take a joke."

His hand moved across the bed in a sudden, snakelike motion, grabbing my wrist with the force of *Spenser: for Hire*. I watched my wrist turn scarlet and pink like geraniums. His wife laughed to see me in pain, the sick pain of the weak boy with no muscles. "Also," she said, "you look like Pumpkin Head."

"Fuck you," I told them. Must have been the steroids, because never before had I found the strength to object to their taunts. They moved in on me, husband and wife, the husband stretching my body across the bed while his wife beat it with the vacuum cleaner cord. They laughed like two ignorant goblins, like the video couple Pac-Man and Ms Pac-Man.

Finally they left, and when Arthur came he found me bound up to the bed, a sickening kind of bruise platoon, blue and green and red, and I was crying. He dried my tears with his bandanna, then said, Well hell kid, you need me to build your body twenty ways. You got to stand up to those suckers.

Don't tell Eve, okay? I want to stay on her good side, said Arthur King, and then he was gone for a few minutes and then he came back with the steroid works. And after that we began deceiving Eve and making my weakness go away, further and further.

Little by little.

Let's start with the way the needle hovers over the flesh, in search of a fattened vein of blue, its tip pointing this way, then that, like a magic cat dick. Once alert, tip touches the skin and then goes through it, invisible, like Casper entering a house, sideways, a friendly ghost, calling out, "Who's there?" in this weak little piping voice like mine. Then the drug hits the blood in this enormous gray rush—a polar icecap breaking up.

For a few minutes you lie there dazed, a smile begins on your face. Stupid grin of these tumultuous vitamins rattling your blood. Like

they're doing the rhumba or mamba.

All through your body. Then for an hour or so it's like your sex feelings churn and ripple to the walls of the room. Out the window a slight summer breeze flickers down Minna Street. Arthur puts down his goggles and says, "Well, it's back to work for me kid."

I love him but he doesn't know I'm alive, except to save me from thugs. And he'd do that for anyone, even the cruel and rich like George Bush.

"Who put that *hatchet* through our front door!" Eve lowered the volume of the TV and turned up the volume of her radio. The hatchet stared out at Eve, one-eyed, like something out of a Harryhausen picture. She grabbed the axe and started swinging it wildly. "Don't tell me, Winston—make me guess."

"I'm getting stronger," I told her. "One of these days I'll be a normal boy."

"If you were a normal boy I'd get bored," she said. "I'd get so bored I'd float right out onto the street on platinum wings."

But despite what she said I kept slipping out, after the moon was up, across the alley to the squat factory where Arthur worked in a lab. In the day time he'd go to Macy's and inveigle my sister on her lunch hour. "I went to Stars," she would say, "and Jeremiah Tower made me a flan in the shape of a radio."

"And Arthur paid."

"And Arthur paid!" she'd say like this was the jolliest thing in the world. Creak creak went the stairs, went my steps down the wooden stairs and the iron door I hushed behind me at night—then into the secret lab where he crushed big filings into the finest powder. "Ever go to Cancun?" he would say, not to invite me there but to tell me how fine the sand was.

A cloud lived in that needle then he would push it down into my body, which responded with bulge upon bulge of love.

Pumped Up
If it wasn't love it was anabolics which pepped me up. I began to be able to kick the dumpsters from one end of Minna Street to

the other. At work I graduated from selecting rice to hauling vast crates of cutlery and cocoa beans from trucks into the basement of Rainbow. My manager said, "Winston, you're living proof of the benefits of natural food and health." Ya ya ya I said, too busy in my brain even to ignore him. I looked like I posed for WPA murals back in the Depression, huge Rivera longshoremen, strikers with shoulders big as hams. But inside I didn't feel strong, not exactly—more like some flimsy bean sprout covered in tempura: big but crunchy, as if one sharp look would cut me up, or a rainshower melt me away into the gutter. I was walking down Valencia when Mahmoud Clinton bumped into me, not seeing me till I loomed tall before him, big as a house, and the recoil sent him flying, bouncing his ass on the sidewalk. He lay in my shadow, his tiny eyes blinking like a bat. His wife rushed up and whispered in his ear, something about me. Then the two of them slunk away while I wiped lint from my lapels.

That night I told Eve about my encounter with the Clintons. "I don't care about them," she said, "but if I ever find out who's supplying you with steroids I will kill him."

"I'm not on steroids. It's just Nordic Track."

"Who told you you could lie to me," Eve snapped. "Next thing your *naga* will shrink up like a seahorse."

"I actually don't have any problem in that area," said I, crossing my legs. It was becoming more and more difficult to cross my legs, it was like humping one big log on top of the other, over and over, like *Seven Brides for Seven Brothers*. "I'm fine genitally," although actually I was wondering otherwise. Were my balls getting bald, midgety, square? Who could I ask?

In June we have the Minna Street fair—booths of fun and games, trying to shoot ducks with pistols screwed into two by fours, other stunts. I decided to lift a thirty pound hammer over my head and pound it onto this slotted scale. Up a long ladder of marks a speeding rocket rose and hit the bell at the very top. Way past "puny," "adequate," "ladies' man," "stud," "Tyson," way past "Arnold" and "Hercules." This rocket hit the bell, knocked it off its cupola. High into the sky it rang, almost at the moon. When the flashbulbs snapped my picture for the SOMA Gazette, Eve and Arthur stood on either side

of me. I felt like, he was becoming my brother in a way, still he experimented on me in secret. Eve came home from Vegas with a big diamond ring and said, "I'm going to be Mrs. King Arthur." She giggled. "I never thought I could feel anything but I do, Winston, I love him."

Arthur was nervous—telling me, "Hey, let's try to blow down on these injections. Not cold turkey, like this turkey salad." But I'm not this leftover you'd serve after Thanksgiving in some Norman Rockwell family get together.

He cut me off—like a man pulling his pockets inside out. Because I loved him I could forgive him, just barely, but my blood couldn't. I needed the lift he had opened in the way of an old time elevator operator. "What floor please?"

You Can't Hurt Me Now—I Got Away from You
I Got Away from You

I missed the wedding because I was around the corner on Natoma Street, buying a tube off this quacky guy from Brazil, then another, then another until my muscles started to spin, gently as pinwheels, all up and down the surface of my arms.

Those complex muscles that could do things. Put a walnut on my forearm and muscles would reach up out of the skin and crack it in two. Then I looked and across my chest my nipples were almost three feet away from each other, like those of two completely different men who hardly liked each other but were caught in Muni, perhaps. I scared myself. Arthur and Eve moved off to a lavish place in Pacific Heights, but I stayed close to the alley, playing my cards close to my chest.

I looked up, bent over a crate of olives at my job, and the Clintons were heading my way. My insides started to turn to mush, and sweat broke out at all these places, new acres of skin. Then I remembered who I was—a hulking stud like Gerard Depardieu only much much more fearsome. "Yes?" said I to the two tiny rats who had made my life Hell.

"Winston darling, we heard your sister is married, how lovely," said Clinton's wife.

"Where she live?" asked Mahmoud Clinton, politely as if this were some kind of tea party.

I extended my hand and made its fingers grow and bend, in the air of the grocery aisle. Their four ferret eyes bulged like black olives, topped with stuffing. Then they turned tail, and vanished past the arugula, onto the street.

I saw little of Eve, after their move, and zero of Arthur King. They sent a telegram that she was pregnant. This yellow square of **HEL-VETICA** type. How could they betray me, I used to say, to the TV screen that flattened my world from 4D to 3D. I kept thinking of them happy as clams, and across the screen a wedding party kept moving from left to right, flower girls throwing roses and lilies to the people in church, and I'm up in the topmost stall like Quasimodo, tears in my eyes. The phone rang. I didn't answer. Maybe it was Eve—she kept calling and sending me money. But she wasn't coming over, she was too busy having a baby—always running down to the prenatal clinic and trying to keep her figure together. After the baby was born she brought him home to the Pacific Heights Mansion.

About this time my strength was challenged and I paid an awful price. Eve knocked on my door and demanded to know my dealer's name. "Matthew Marks," I batted back, ha ha. "OK, your pusher then." I told the truth, you can find them on any street corner and every other locker room. She said, "So Arthur had nothing to do with this?" I hesitated but then my loss and my grief and envy came over me, clouding all my feelings. "A little," I replied. "I see," said Eve, slapping her gloves together.

I tried to explain but she got past me. The Clintons stole in, just after dawn, when Arthur lay snoring in this ornate featherbed from Macy's.

Eve was in the bathtub, the lights down low. Her radio stood on the wide rim of the tub, a buzzing box of lite rock. Madonna singing something sad as her mood. "You can't hurt me now, I got away from you."

Turned down low so as not to wake the baby boy, nor Arthur either.

Wonder what she felt as they came toward her. As they pointed

fingers at her lovely body. "I got away from you," Madonna repeated, "I got away from you." Then the radio hit the water with a sizzling crackle, and Clinton laughed. "This," he intoned, "is the mad universal runner that crept up your stocking."

A smell filled the bathroom—a horrific smell, part toast, part fat. Part something else. A burning smell, sharp as autumn leaves. Soggy. Clinton watched my sister with satisfaction for some moments, then turned his head to direct his wife's operations.

A pair of bubbles burst at the level surface of the bathwater.

"I've got the baby," said his wife, rocking the shapeless bundle on her hip. "The famous King baby."

"So let's slam outa here."

"My sentiments exactly," said Mrs. Clinton. Not for the Clintons any of the required child seats needed by law, they put the baby on the back seat and let him roll around while they careered from career to career, as the song goes.

The car turned a corner and Mahmoud Clinton stopped to light a stogie. I reached into his open window and grabbed his neck, pulling him out from the window with one of my hands. His shoulders stuck. His little head pulled slightly from the frame it was set in. His wife tried to run out of the passenger seat but I delayed her. "I am he whose life you stunted, whose weakness lost his sister her life," I told them. I was so upset. I had the body of a giant but my mind was still that of a flea or pipsqueak, I felt, me no deserve to live. I remembered the 3 Stooges cartoons boys love, and knocked together the Clintons' heads until both fell to the gutter. The baby climbed into my arms as I thought of Eve and wept. I thought of her body as it shimmered through a veil of electric water, blue, white, and black. Her beloved radio sending her transmissions from the invisible world.

Goodbye my beautiful sister. *When we are together*, she used to say, *we are so strong*. We walked through the Castro down Market to Eleventh, me and this baby, a boy so small he looked like a dot on my shoulder. At the corner my Brazilian pal hailed me and sold some steroids. I took the baby to Arthur's lab and set him on a big black table, spread with calipers and torches. He was

crying and I couldn't.

"Mother," I called out, "take care of Eve in heaven." What I did was done in the name of love, beyond good and evil. My skin felt tight, overstretched. On TV Richard Brown and Terilyn Joe were talking about the "derelict couple" found squashed like pumpkins in Pacific Heights. Why don't they ever say "cruel couple"? But oh no, they always go for the sensational. Flat on his back, the baby squirmed against the buckles, the restraints. Sometimes he slept. I bared his throat, in the shadow of the glass chromometers. Finally after the night was over Arthur came to the lab and took me in his arms. His mortal arms which couldn't reach round my ribcage. I looked down at his blond beauty and craved to be a normal boy. He said Eve wasn't dead after all, but resting in the hospital with 3rd degree burns.

"She told me to tell you she'll never leave you, Winston. She will always save you from harm, from this moment forward. Just give me the baby—that's the boy."

I am the zero which, by itself, is of no value but put after a unit becomes useful.

Philosophy
(for Nayland Blake)

Spider.
What I liked about Ian was 'is soft slow way of speaking. He was a bloody savant, always 'is neck in a book and talkin' posh, like 'e swallowed a dictionary. He showered me wiv respect, which none gave me heretofore, for I was a lad o' the Gorbals, a grotty section of the City of Manchester. I been had up twice on petty offence against the crown. Both times I played the nuts, cobbed a skinner. All I became I owe t' the patronage o' Mr. Ian fuckin Brady. He took interest in me where others found none, except my mates and my wife, Mo.

Ian and me are married to two sisters, who were very unlike. Our Ian pays the rent as a secretary, downtown where all the lights 'r' bright. Got a lovely white minivan parked in the car park, bought wiv some installment plan fiddle. Never could cop on to what Myra's all aboot, she's writing a bleedin' book, *The Letters of Myra Hindley*, or some rubbish. *Dear David Smith*, she wrote me, *leave your bloody hands off my man, don't come near our cats either, Puppet or Bruce.* Bang goes the holiday, back wiv luck. Never could take a joke, our Myra.

Mo, her sister, my wife that is, was a lovely sexy eighteen. As Ian always said, nature will find its way. Our Mo was a one, she was. We 'ad a smashin flat 'igh on Bermondsley Terrace, where Ian an' Myra walked up for a housewarmin' booze. Whenever Ian got onto one o' his p-pet things, talk about gift o' the gab, he'd fix you wiv them eyes an' you gave 'eed. Soon I was out of work and the rent was due sometime ages back. Bloody landlord makes me an offer and says, clean up the hoardings, come t' my parlor with knickers lowered. Concerns a little rent matter. I'm slim but husky for sixteen, not as tall as Ian but five-nine and more, brown

eyes, dark hair with fair streaks, nice straight nose, big sulky mouth till I smile, then it lights up. And when I giggle, sound like a kid.

Ooh, that fookin booger landlord. Give us a kiss, say he, round midnight at the Lancashire Road.

So I agree, very simply. Ian finds out, he catches my shoulder in one hand and p-puts his hand on my heart. "David Smith," he says, "are you daft o summat? Can be a challenge to that sort to nip a lad right out o' the orange blossom." We tell pal landlord bugger off. Ian nudge me "You ready for this, young David Smith?" He catches up his cock through his fly buttons and thrusts it towards me, a curious big bouquet I reject. "Sorry, luv," say I, "the sun's not over the yardarm. Fanks—but no fanks!" Then 'e indicates 'is volume library, the works of De Sade. 'E is the master, says Ian, of continental how shall we say.

I wouldn't mind some o' the how shall we say, spread out creamy, on a cracker or two.

He says, well, French isn't in one of your vocabulary, I'll translate off the cuff. Me 'n' Myra are home tapin' tonight, so Saturday will do on the dole. Ta, David Smith. Sobering up I had to nod. No French for this lad, it's a fuckin' bloody hell.

"You haven't lived till you've been on a sex kick," said Ian, a wee smile altering his foxy countenance. I found his dick a little ripe, and peculiar, as though the base was a weak noodle and later on did it pouffe out to the 'ead, like a loaf o' bread on a string. "Put your mouf on me, David Smith," he say, nearer the mark than he knows.

Wiv his ole bag o' tricks stuffed in my mouf I'm in no position to reply. Afterwards I sally forth, home t' Bermondsley where our Mo awaits. I *have* 'ad a raw deal, we all 'ave. "Mo," I say, "our Ian's a queer duck, int he?" "He's dishy," Mo replies, a la the queen of Sheba.

She tossed her head as if to ward off any more such "compliments." But I spoke in sincerity. My tongue slid down again to lower itself towards her thighs, and the traces o' this scent, musky and fruity at the same time—like a kind of liqueur I'd never swagged—beckoned me on. I shut my eyes while her vagina opened up, unfolded, before the thrust o' me enormous tongue. A queer kind of p-power without the power o' denial behind it.

Filaments flowed between me and Mo. She pushed hard on 'er

elbows and I bore down till my shoulders touched 'er knees.

I'm reading De Sade daily per our Ian. He assigns me bits nightly, and I take notes gorgeous. 'E turned back the bedclothes, wearin' some excuse for underwear. Explain me that book, say I, that 180 Degrees of Sodom. HE SAID THAT WHAT SHE REFUSED HIM HE WAS GOING TO TAKE BY FORCE. Turn me around, it did, wiv its rough action and its no holes barred. I get excitement at 'is knee. Listening t' you, *crunch*, I get the feelin', right behind you, I get the story, from you, *crunch*. . . . This old lag, says Ian, lived a right proper old spell in days of yore. Sade believes that pleasure is power and the effect o' the strong can startle the wits from the weak's head.

"Rape is not a crime, it is a state o' mind. God is a disease which eats away a man's instincts, murder is a hobby and a supreme pleasure." He asks if I David Smith, 'ave the intestinal fortitude, really to hate? "I like you 'n' our Mo, and Myra I suppose, and there's a fair quire I don't care for, and yeah, there be one or two I hate, Ian."

Let's see you and me plug that same 1 or 2—together. We'll bury their wretched bones in the peat o' the moors.

I say, bury your bloody peat in my moorish hen. Not catching 'is drift like.

"My dear David Smith," repeats our Ian, "ah, the sweet illusion of bein' no longer a man, but a woman! What delirium t' be, during the same twenty-four hours, the mistress of a porter, a Marquis, a valet 'n' a Duke." Little man, think I, you 'ave had a busy day. See that door there? If that door was barred an' bolted an' he was on the other side, he'd break it down into splinters to get at me.

Mo rings up, the doctor's been round wiv some o' those pills the rave is on aboot. "Gimme a git," I bespoke before p-pulling my old flannels over my bare legs. I'm not a man to take lightly, even wiv Ian. He shows respect as befits a man married to Myra. I see her pale blue eye through the knothole, fuckin' bloody hell, she's been a porthole in my secret storm. On the old nap and tinkle I pass by and apply force to her eye, the gooseberry fool o'

Wellington Street. TA!

It was as though only two people lived in the universe and she was Inger Stevens and he was Harry Belafonte. When Myra went down on Ian, a bubbly foam broke and played on his thin sensitive lips. The smell that rose up from his mouth was unlike any others. He broke off and told her sell this in a bottle you'll make a fortune from the Indians.

Ian 'ad me to Number 16 every night. Learnin his favorite Sadeian bits. *The consciousness of doing wrong is what excites the wise. The greater the atrocity, the greater the passion.* 'E was in crackin' form, was our Ian. "Thot of someone I do hate, Ian Brady." "Oh? Fuckin' who would that be, David Smith?' EDDIE EVANS, I EXPLAIN. EDDIE EVANS OF ECCLES STREET. Tell me aboot Eddie, what's his M.O?

Made me say his name, Eddie Evans. Now I will tell you what I told our Ian aboot Eddie Evans. 'E had too much personality. 'Is feelings were too strong, I didn't care for that.

He was a lad my age, the toes of 'is boots were square, black and round, correct for kicking in a roughhouse, but not him.

His black cloth pants were tight and pulled up to resemble a coat o' black paint sprayed square and round along his legs. Eddie Evans, 17.

I exchanged a word wiv him in the Barrowford Bar, in town, a hangout for homos. It amused me to watch their antics. Quite comic, really.

They should be stripped naked and tied with tape to the ceiling, genitals dangling.

Fly.

Me and Myra 'ave already put paid a dozen youngsters from here to 'Ampden Junction, Ian lets on. We took to it like ducks t' water, the slaughter of innocents that is. Myra preens. Ian takes a wee dogwhip 'n' applies it to her back, saying to me, David Smith, you would be wise to chastise this white woman's sister likewise. I'm impressed. "Myra's a bit of a cold fish in some areas. Like one o' them fish who never see the light they're down in the lowest stratosphere, so all they see is black, and their eyes are like these white flat hard peas from the market. That's our Myra. Put an idea in 'er head, watch it bounce up 'n' down

the whole cube of 'er skull." 'E enflames my balls and torso with skillful reading style, 'e does. One night I tore through the Barrowford Bar, expecting to find pal Eddie. There indeed Eddie wove through the knees of a gang o' men on barstools, leaning over their tall G & T the better to ogle artful him. I cup my hands over my mouth and nose and speak into the hollow. "Eddie," I intone. "Men will not look at you again as they did tonight!" I'd like to see him wiv all his clothes off, stripped to the skin and strung from the ceiling wiv cellotape, 'is balls dangling from his body.

EDDIE EVANS. His p-personality was too big and loud, always one for a joke or a laugh, just when the woes tumble down your head. His lips were big and red, and my whole story was tumbling down like thoughts—the red lips in the crack of 'is ass would a fire make in my little tumbling conner. 'E don't look half far-fetched, do he, bless him.

Into the smart white minivan I bundle wiv Ian, two queer ducks wiv six bottles of red wine, and the heavy black bag he carries his revolver in. "Lookit," say our Ian, pointin out two holes the size of a shilling, drilled into the side panel. Binoculars fit the two holes neatly. "Well, I never," I sigh, applying my eyes to the lenses. "Ian Brady, do you spy up the dresses of the birds?"

"Think again, David Smith. You'll never wear out a brain you bought on hire purchase."

'Ere was the section o' curb Eddie Evans make his turf. Twilight, and the long shadows of the coffee bar spill out. Ooh, he's naughty—he needs a good smack-bottom. "That coffin was just made for you," I snarled. "You look swell in there."

"Fancy a drink, young Eddie? Coom on, Eddie, don't spare the blushes, you are the ruddy limit." When 'e is tucked between us we each grab us a knee. 'E is suffused wiv red pleasure in tight black jeans from Armani Emporio. The white minivan proceeds onto A90. Nice to ask the kiddie in, bring a bit o' color into his life. 'E's got a homo way o' thinkin, that homo aperture, 'is hands 'ave faint ginger hairs on 'em, a pair of gloves stuffed in his pocket, blowed if *Puppet and Bruce* don't leap up 'n' start yowlin like something wild on telly.

"Scorn the laws," Ian said. "Scorn God!"

I tied his arms, and wiv quick birdlike movements Ian started pricking them. Never for a moment did 'e take 'is burning eyes from the blood that dripped from Eddie Evans.

"When you 'ave finished your crime," said Eddie, "will you find happiness in my tears and my disgust?"

I dunno what rightly put the thought in my 'ead, cheeky monkey. A combination of t'ings, I expect. No work, no dole, no chance for change. I'm bettin' on you to start up a drug ring, says our Mo. No, Mo my girl, too tame, I fancy the slaughter o' the Evans lad from Eccles Street! I stumbled into a nest of vipers at Number 16, our Myra and Ian. Tho' some there are who remembered them wiv the gratitude o' the long-ill and lonely. Beware, boys my age. There are devils among ye. Our Ian met Jerry Brown at the benefit for Small Press Traffic, copped his autograph, and Jerry wrote in Latin, "Age quod agis"—Do as I do. My consignment of adolescent flesh and heat loses its warmth in the cold o' the clay. The trousers were rolled down to the knees, and the undershorts down to below the thighs. The undershorts 'ave then been pulled down from behind to the full extent o' the elastic band and then knotted hard behind the legs in order to p-pin them together. No more, the case is complete. "I have all my life had leanings towards Vice; and any fellow-creature who gives proof of a gift for Vice, I look upon a a Great Man."

Sexual Threat.

At times like these Ian felt there wasn't much connection to Myra, that they were almost, if not quite, strangers. She paused in the doorway; 'e had then the time 'e need to take her in, as it were, and she seemed—her features, the swell of her body—to jump out at him like a mugger from behind a pole on the Underground. The thick cloudiness of 'er expression altered; she eyed him curiously—then, wiv one forefinger wet with saliva, lifted the 'em of her green dress to 'er knee, then higher to reveal one thigh. 'E moved through the linen 'n' wool o' the bed toward 'er, like a snake through tall grass, tongue wriggling like a snake's. She shifted her stance slightly to squeeze his mouth between her knees, as 'e tried to speak and tried to lick 'er skin from

inside. Suddenly she gave up, let go, and fell against the doorframe while 'e licked and bit the fine gold nest of 'er cunt, the walls of which undulated against 'is mouf like the wavery heat of a furnace. And Myra's body sank to the bed and 'e climbed on top of 'er 'n' fucked her through 'er flimsy underwear. "Excuse for underwear," he joked, to make 'er respond. His cock could feel it, when she took in 'is words. Ooh, that fookin booger.

Last time in the minivan I pass a remark about 'is 'ands, an' Ian waves 'is fingers about: "Yes, they're good hands," he says, an' then I says, "Different than mine which are very bad 'ands an' you never know where they'll land next," an' suited the action to the word. Well, I got a stingin' wallop across the kisser and he was out o' the car, bang, an' off on them 'igh 'eels an' that's the last I 'eard of 'im.

And de Sade told me: Nature is sufficient, and needs no creator—Did not Romulus permit infanticide?

And Ian said, "Religion? You will find here only cruelty 'n' debauchery, submit!"

Eddie, do I hear ye say I was horrid? "For outcasts like ourselves, there are only two courses, crime or death." Our Eddie, "Here! Stop him fouling my carpet runner, his dick is wet, you 'ave a go." Summer storm splashes the dry airless minivan. Myra was right steamed, but Ian quotes de Sade: "Why should a woman enjoy while a man is enjoyin'?"

To relate some details of Eddie's death at the 'ands of Ian. On the floor next to the couch, a screamin' figure—Eddie Evans—writhed on its stomach while our Ian stood carefully bent astride it, holding the back o' the neck in one hand and in the other, something wiv which he was flailing the back of the head: something movin' so fast that for the first couple o' seconds it was impossible to see what it was. An axe. He was smashin it down—not the edge o' the blade but the side, so as to save blood—time 'n' time again and with all his strength. A butcher felling a calf.

My split second impression is that my friend was playin' a grim practical joke, wiv some sort o' life-size doll which 'e was

pullin spasmodically aboot on the ol' couch t' make the limbs twitch wiv uncanny life. You dirty bastard *crunch* you fuckin' cunt *crunch*. Then it came to me, like an electric shock, that th' *soi-disant* doll was in stockinged feet, spouting blood all over the room, screamin' for mercy, wearing jeans, and was Eddie Evans, a lad my own age. Asked in court what I did when I saw this, I replied, "I moved." The screams crumbled into groans and gurgles, which in their turn were swamped by a sound like when you brush your teeth 'n' gargle wiv water. He look like a marionette, strings cut. "He's a goner," I said. "We'll have to get rid of 'im." Ian Brady then took a cushion cover from where it lay ready, bent down, lifted the boy's head by the long wet hair and cautiously p-pulled the cushion cover over it. He then took a length of electric cord, also at hand, drew it around the neck and pulled it tight. The rattle died away. The marionette, with the blood already seepin into the mass o' the cushion cover, lay still.

It wasn't always easy to satisfy Myra Hindley, but sometimes Ian found it so; there was the spring night she came home late, tired, elated somehow, with a thickened light filling her face. 'E lay in bed groggy, he'd had a long confusing dream about a saucer o' milk and a millionaire's will. "Why did you preserve this tape?"
"Because it was unusual."
"Because it is my philosophy,"
Now some detail of the torture of Eddie, precedin death. The rafters of Number 16 were crusty with age, broad oak beams datin' from the Cavaliers. To these rafters the nude body of Edward Evans, 17, was applied, with tape, so that if you 'appened to look up like, you would 'ave seen him squirmin' against the rope 'n' tape, his genitals dangling, so if you was one who might enter a dark room and reach overhead for the chain to turn on the light, so you would 'ave grabbed his genitals and yanked them.

As did so many men during 'is short tenure on earth among us. "Eddie Evans," I allege. "Men will not look at you again as they did tonight!"

His eyes went wild with fright. 'E was deeply attached to me, but certainly not p-passionately in love wiv me. We 'ad a good deal in com-

mon.

I took his black boots and held them near his face. "I would shine your shoes, Eddie, but you will not be wearing them except when they bury you, maybe."

His face was red from lividity 'n' all that bollocks. To speak he must cough up a little and loosen 'is adam's apple from the tape that held it to old rafter. "David Smith," 'e said, "you repay my caring side wiv the treatment of a fiend."

"I'm not alone in this," I reply. "Ian Brady did not hold me at gunpoint, exactly, but his say-so was the say that said." For if truth be told, I did not know how fiercely I hated Eddie till our Ian dragged it out of me by force.

"David Smith I wanted your love and approval, instead you have turned against me with beast Ian. Almighty God, is it thy decree that the shiverin innocent shall become the prey o' the guilty?"

"I feel your cock and balls in my hands," say I, "I squeeze 'em like playing dough, if it takes my fancy I might swallow them up like so many chocs. It is the prerogative of the mighty 'n' powerful, to eat the genitals of our prey, and so help me, Eddie, I might indeed, to answer you for the evenings I would watch you swish up 'n' down in the Barrowford Bar like a tart, attracting many men wiv your red tongue, the white round fire of your bum." I gathered up 'is clothes what we had tore from his body 'n' continued: "Indeed, Eddie, I 'ardly know what keeps me from such a meal, except I have to p-piss first, into th' black chimneys of your empty warm jeans, here goes."

"Well do what you want wiv me, I guess," said Eddie when I had done. He spoke with obvious resignation.

"Ian will return and want his captive unsullied, young Ed—otherwise I would."

Tho' we did not speak these words, they represent what we saw, 'n' thought n felt. "I am yours since I am weak, and bound," said Eddie. Drool from his mouth fell straight down onto the carpet where I crouched. "Indeed I 'ave been your property, as you might say, ever since Borstal School where first I made your

acquaintance in lock-up. Destiny strikes the high 'n' low wiv the same grand climacteric, and this is my time."

"Property," I told him, "has no time," and once more I reached up and flicked his raw dick with nimble fingers. For me, a stream of pleasure; for our Eddie more agony. I looked at it as if it were mine and I screeched, like the two cats of Ian and Myra when a tin of kittles is opened with steel can opener.

—after Emlyn Williams' *Beyond Belief*

Who Is Kevin Killian?

... I'm always reading the *Chronicle*, every morning, at work, and I saw how the guy died, the guy who invented sodium pentathol. And you know, I felt bad for him. Didn't realize he was still alive.

Did you know him?

No, as a matter of fact I didn't. I mean, sodium pentathol's been around so long—part of my consciousness, you might say— I never realized any one person actually must have invented it. Like last year when the obit columns said the man who invented the Tequila Sunrise died. Same thing. And two years ago this old Swiss nut who had thought up Velcro. But with this sodium pentathol guy—maybe he was in Chicago, maybe it was some kind of offshoot of the Manhattan Project—I really felt bad, not because of anything pertinent to my life—I just got swept away with thinking how pathetic life is, that you could do something and nobody would know it, and how eventually you die and eventually everyone alive who remembers you will die—then you really don't exist any more. I remember Jerry Ackerman telling me he had written the life of Gerôme, the French painter, and he found one ancient old woman who had actually met him—and she was, like, three-and-a-half and she'd sat on his lap for 15 minutes.

I found that so pathetic. After she goes—and, who knows, she's probably dead now, because this was some time ago Ackerman met her.

Well, but his work remains—although I don't know it myself.

Yeah, I guess so. That's a nice tie you have on. No, I mean it. One doesn't often see fabric like that, is it naugahyde? But anyway that's when you said you had some pentathol I said, Hell, why not, let's do it in memory of this *guy*. Shitty thing is I don't even

remember his name. But I'm almost sure he worked in Chicago.

I don't know Gerôme either. He's one of those big, blowsy French romantic painters, Ackerman's the expert on him. I guess they all have one expert on each of them. It's funny that here in the City there's this painter, Jerome Caja, they just call him "Jerome,"—just like the French guy! He's got this show now at Southern Exposure. Jerome does all his pictures from makeup—he's into drag and shit. Anyhow—oh, and all the pictures are real little, like a few inches square, because I guess, because of the price of cosmetics. So at Southern Exposure he had this show with this other man, Charles Sexton—and Sexton died—and he said to Jerome to have him cremated and give the ashes to Jerome, and make pictures out of them. And one of the pieces there is this ashtray—like that—filled with Charles' ashes and Jerome painted this little tiny picture of Charles at the tip of one of the cigarette butts in the ashtray. Isn't that gross? I don't know why, it gave me the creeps.

I really like that tie. It's very sensuous. My dad had a chair like that. Who gave it to you?

It's silk.

Did somebody give it to you who loved you, must have been, it has that feeling coming through it. I like the blue and the yellow. Steve Abbott had a few of Jerome's pictures, and Bruce and I were talking about, well!—about what will happen when Steve dies—because we have to sell his stuff for Alysia; and gee, I guess all he really had are books—*and* these two Jerome pictures. So we were so depressed thinking about the day coming wow, Steve will actually die. And you know how when you're down in the dumps, brooding, sometimes one of you says something absolutely tacky and you both crack up. Well, we said we would charge the estate the rental of a helicopter—because we'd have to fly the books to Berkeley—and then each take one of the Jerome pictures, and we'd tell Alicia, *gee, I guess those books weren't worth all that much but here's ten dollars.* Oh, it was awful, but we were cracking up. Don't tell Alysia.

I don't know her. Otherwise I would.

Oh, she's really sweet. I guess I always say that, about people. Doesn't give you much sense of her character, does it? I'm a jerk. No, not a jerk, but sometimes I feel very inarticulate. The people I admire speak well: speak rapidly, firmly. They use intellectual precepts. But isn't kindness the important thing? You know what Cat Stevens said, we're only here for a short while. You don't get love without you give love back.

So in your heart of hearts you're kind of a drip?

Well, I'm sentimental, "drip" is in dispute. I cry a lot, these tears well up constantly, especially when I see *West Side Story*. When Natalie's on the fire escape and says, "Te amo, Tony," that's when I start to spout, like a geyser or a—I don't know—widower or something. There's always this displacement between the characters of my fantasy and the sentence I'm stomping around in, wild, big-footed, like Lucy and that Italian woman turning grapes to wine.

There's not much I want to know about you.

There is something I want to get out of my system, as long as I'm feeling this pink—way.... I remember Lynne Tillman has this analyst for so many years she was totally transferred—I mean this woman was like her mother. And one evening after she got home Lynne did this double-take, her key in the latch—remembering the funny look on this old analyst's face right when they said goodbye. It was the same look Lynne's father had had one night when he went to bed and he had this tremendous stroke. So Lynne rushed to the phone and all night long started calling her analyst, no answer, finally she took a cab all the way uptown or wherever and there was the ambulance, pulling away, and sure enough, she had had a stroke and—you could predict it from an expression? ... It's not only your tie, it's your whole ensemble, the finish of your package. Henry James could have invented you—no, Abel Gance; but your gilding, the embonpoint, those Henry James might have supplied.

Thanks. In your stories there's a recurring figure—a drugged or otherwise helpless male, married off, without his conset. Does this have anything to do with your own marriage to Dodie Bellamy?

Hey, I—gee, I wonder... never thought of it like that. Maybe. I guess. You know, that's the writer's unconsciousness bubbling up, like

goat's head soup, right? But hey, I'm forty years old, I've been on drugs all my life. Every day I remember less, it's like dissolving. So life is like a drug, my consciousness has always been impaired, but also magnified I suppose. What happened is I fell in love with her, I know it's odd and everyone said it wouldn't last, not to my face of course.

Although people say such mean things to one's face I'm surprised that wasn't one of them. It's just that I'm gay, why get married?

Maybe you're afraid of AIDS.

Yeah well sure. I was really frightened, for myself, then after those tests less frightened for me, more frightened for the—whole fabric of society. You know. I felt this funny twinge of fear when Anthony Perkins died. I saw myself as one of those pathetic figures in the *Midnight Tattler* who say Richard Simmons paid them money to spank him. Or Merv Griffin had them dress in cellophane on Easter Sunday and pelt him with painted eggs. When he died I got the cold shivers. I met him on an elevator, in a hotel in midtown Manhattan. A winter afternoon, not too cold. I was all agog, fairly bursting with excitement. Of course I thought of him as Norman Bates. He was taller than most people in the crowded elevator. This was during the MLA Convention, of course. That's where all of us sexual deviants went every year during the 70's. It was like—the Mineshaft and the MLA.

It was one of those cases where one thing led to another, but it was definitely my chasing that did it. Now when I see him on television, which is like always, I really get cold. Not that he was so good-looking to begin with. He kind of looked like a tortoise face, like the happy turtle who played a guitar they used to have on cartoons when I was a boy, I can't remember the name—like "Touche Turtle" or someone. And he always plays this weirdo, like Jim Pearsall or whoever, I mean Norman Bates was the least of his problems. He was a busy man, there to see his old friend Ingrid Bergman. Who I also got to meet. She was raddled with cancer, but still luminous—a Mexican lantern you plant in the sand.

Why do you love the stars so much?

. . . I can't really answer that. I don't know. That's a side issue. I guess the worst thing I did was this one star, I wanted his autograph terrrible, and nothing seemed to help—I mean I wrote letter after letter, pleading for this autograph, and then I caved in on myself and said I had the HIV virus, and right away, snap, he sent me this long letter, saying to me, don't give up, a cure's right around the corner. I felt so guilty. Also it seemed like such bad karma, know what I mean? I had to take another test right away. It just seems like a miracle. I remember telling Nayland about this incident, and how bad I felt, and he was saying, "Oh that wasn't such a heinous," you know, "thing to do, Kevin," but his eyes were just shocked and all the color drained out of his face no matter what his mouth was saying. I mean I remember being on top of that bar, so drunk I couldn't see, with the bartender straddling the bar. . . . Couldn't remember if he'd had his dick in me or not but I assume he did, I assume he came. I remember him jamming this thing up my ass, this crazy thing you squirt different mixes with, ginger ale, Coke, etc., this long wily thing lives at the end of a metallic kind of telephone cord, and it was like—whoosh! Ginger ale, whoosh! Lemon-lime or whatever—water I guess—and him saying, can you tell what this is when he'd press each button. And drunk as I was three times out of four I could guess right.

Like those Russian ESP experiments when they hold spades and hearts behind their hands up to their heads real hard like they're concentrating—anyway, you can see why I was nervous, especially because within six months this man was dead, dead of AIDS, and I was trying to stay sedate, not to panic.

Or that Argento picture that opens with the psychic, seated in front of an audience in one of those grand European halls that looks like an opera house. Suddenly she calls out, "There's someone in this room with 'danger' attached to him!" She starts mumbling about this child with a knife, a Christmas tree, this terrible danger and blood—the crowd goes wild. Oh I know, it's *Deep Red—Profondo Rosso* in Italian. It figures with Argento it's a gay guy who does it in this one, no it's not, it's his mother, that's right, well, what's worse? Me and Dodie were at Just Thai with Kathy? Acker? who was telling us all about Argento and how marvelous and sick he is, this led us to watch

oh, all his shows, they're so disturbed and sick and luscious.

Do you have sex with a lot of men?

It's like, she thinks of it as being faithful. I don't, but I do it anyhow, because I don't want to hurt her. That's the only reason. She says, you're in love with that boy, or that man, and I say, like, no. I'm not. Why aren't you? she says. You're gay! I say I don't know, I'm in love with you. She says, it's not natural, how can I satisfy you, you're gay! So I'm gay, doesn't mean I'm a cheater.

That makes it sound like I think I'm better than cheaters, I'm not. I used to depend on cheaters. I liked nothing more than playing *back street girl* to some married man. They're safe. They don't want to rock the boat, yet they're torn by these tremendous longings. And now I'm one of them myself but I learned from their example. I guess you could say I'm the new improved model. Oh and Kathy's new book has this huge incredible section that retells the plot of Suspiria, the weirdest of all the Argento films, only she calls it *Clit City*. Am I talking too fast?

No—*I'm getting it all down. Did you really see those pictures by Jerome Caja?*

No—but Rex Ray and Glen Helfand told me 'bout them. Isn't that the same thing? I mean, Southern Exposure's not on my *route*.

And then Dodie and Bob went, with this visiting priest from Italy. The jet set priest who told Dodie she looked like the young Iris Murdoch.

This sent her to the bookshelves and she read *Nuns and Soldiers* and *The Italian Girl*—gobbled them down like candy.

And this priest is so charming. We were sitting around this white garden table at lunch, him sitting there with this urbane smile as if to say, "I know everyone who's anyone, try me," but I couldn't think of anyone Italian, off hand, and I said, "Do you know Dario?"—Argento—and what d'you think, he says, "Yes, he was one of my students." like in high school, "and so was Cicciolina." Can you top that?

But why do you lie?

It's not lying, it's a—an attempt . . . to do something about my

life. Before Steve's death we would go to the movies, or rather he would come by in a cab, just this one fleet that took those voucher tickets—his eyes were so bad he could only watch movies not TV. He said he was having this one dream, over and over, took place in London, where Mama Cass Elliott died, and he was this flake of ham lodged in her throat. And we were watching *Encino Man*? And he was too tired to get up after the picture was over, and so we just sat there, and I saw this big bucket of popcorn that these people left—they had hardly touched a bite—so we sat there and he told me about this one time, he had gone to New York, there was one person he wanted to meet, to make a pilgrimage to, and this was Helen Adam, the poet. And she was about eighty-five at the time—but still spry,—it must have been ten years ago. And Steve says, "Kevin I thought I'd tell my grandchildren about meeting Helen Adam and now it looks like just the opposite," and I said, "Well, I'll tell your grandchildren if you can't. Or she can tell them about meeting you, Steve. Because she'll outlive us all if she's such a diva."

You eat food other people leave behind?

It just doesn't seem as important as the show. I have this one recurring dream that my fingernails keep growing—they grow all around the world, and stab me in the back. What's that about? In another I'm walking across this rickety bridge of life, and knives are flying everywhere, and some people are stabbed by them, some get to live. It was Halloween, I think, and David Rattray came to town. I had never met him but Eileen gave him my phone number, well, he was awfully nice, and he came to town and read at the store, he was like this weird spaced-out cross between Dario Argento and Anne Bancroft—I wonder if he was Italian. Afterwards me and Avery went to have a drink with him, he was telling us about all these drugs he spent the sixties doing—oh first he said he'd written this story about this very chic 20s lesbian in Paris, like Natalie Barney, killing her girlfriend, did I think it would upset the lesbian community here, in San Francisco! His head was large, and his eyes were these—pools of darkness, though he spoke very sweetly. He was from Long Island like me. Then Dennis came around a month ago and said Rattray fell down in front of his house and he has this brain tumor, and what can be done?

And then Kush over there called up and said, "I have sad news to report, David Rattray is dead." You know, he was courteous. Michael Palmer said he visited Rattray in the early sixties, and he scared Michael, but by now all the fierce wild horror stuff had burned out of him except inside his brain I guess. I'm glad I got him to sign my autograph book, but that sounds so shallow, doesn't it?

I'm not here to pass judgment, though tradition says I should.

When I was young I had this friend, who was very powerful in my life. He made me do these things I wouldn't want anyone to know about. Things I hated myself for doing. But when I did them I got sexually stimulated.

Should I stay or should I go?

Oh that's okay, you go and sit down, but I want you to come back, you hear? I need you to imitate this powerful friend of mine later. "Now you take Philip Mandel," said my powerful friend. "The kid's a clown, but he's not all bad. Lives in the Bronx, right, he's got nothing going for him. Lives with his Mom or some shit, she's an immigrant I guess, she's fucking got garlic and cabbage on the stove all day. Works at the Museum which is no job for a man. Sometimes he shows up in the office smothered in some fairy Chanel perfume, and you know why? and you know why? To try to hide the immigrant cooking smells, but like covering up shit with sugar, some things a man can't hide! Christ, no wonder the kid's a mess. Envy eating him up. Just like it's eating you, Kevin.

"I know. I know. Because like, I used to sit there in Hammond, Indiana, only thing I had was hot nuts. I felt that I'd never get out of that house. Fucking *Chicago* seemed like Paradise. House filled with tubs of laundry—other people's underwear my Mom had to scrub the comestains out of, and why? To put groceries on our fucking table, and I tell you, Kevin, I wanted to kill all the lousy motherfuckers. The rich folks from Hammond Heights in their Caddies, I wanted to tear their heads off, shit down their necks.

"Mom, she had to kiss the ass of every one of them, otherwise hey! Hammond's got other *laundresses.*

"So why," he said evenly, "why don't you go up there and schmooze with him. He's just asking for it and although he's not my type, I wouldn't mind watching the two of you, you know?"

"Fuck *you*."

"No honestly Kevin!"

I'm a friend of Philip's, I told the woman who came to the door. Bits of vegetables clung to her damp pale forearms, I guess vegetables just kind of cling to one. Face to face we stood there for a long moment, before she recollected herself.

"I'm his ma," she explained. "Fixing dinner." In the humid air, just as my friend had foretold, hung garlic and cabbage, and another odor, too, tangy and bitter. Herring perhaps. Goldie Mandel seemed overwhelmed by my car, a 68 Mustang with nothing to live for. As I came into the house, I had the chance to study her further, a chance I welcomed, since my policy was "Know the opposition." In profile her face seemed doughy, irregular, in that her chin was slung back under her jaw like a bridle, and her rough, orange-tinged skin had some of the hard sheen of a ripening pumpkin, but her sharp velvety eyes missed nothing: she should have been a reconnaissance gunner instead of a mother. "Phil's taking a nap. I see to it he gets his rest."

So saying, she ushered me into a parlor which shared some of the traits of the waiting room of a doctor's office: low ceiling, subdued lighting, three or four glossy, but out-of-date magazines spread across a black, square table in front of two straightback chairs—Frank Gehry kind of chairs. "Philly works good and hard you know."

I remembered his languid impassivity at the museum office and marvelled once again at how easily the young seem to be able to deceive their parents. "Indeed he does," I hastened to agree.

Soothed, Mrs. M. favored me with a slight smile. "Sit, Mister? I fetch the boy."

"Thank you," I said, and busied myself with an old copy of "Modern Romance." *I Gave Myself to my Doctor*, I read. *I Needed "Crack" to Keep my Husband Free from Pain.*

"Mother, please, you *know* about my beauty sleep."

Philip's mother, her marrowlike face flushed with excitement, burst into his bedroom breathing hard. Her hands poked into his side under the blanket. Shaking him, she took inventory of the dark room. What had to be straightened up before I could be allowed to see it? She didn't want me to think she kept a sloppy house—that would never do. While Philip rose from his dreams, she began systematically to pick up the clothes that lay strewn across the bookcases and the armchair, meanwhile humming a popular song.

"Sit down to dinner, it's hot and ready. Look, Phil, look at the flowers your friend bought for me."

"They're beautiful," Philip allowed.

"My mother always told me, don't come to visit with empty arms."

"That's a Hungarian expression, was your mother a woman of Hungary?"

"No," I said. "She was an Irish colleen."

"Like Maureen O'Hara," said Mrs. Mandel.

"Or Sinead O'Connor," I said. Dinner was tasty as anything you'd ever eaten at the UN Embassy or somewhere. Who knows what it was, some kind of Eastern European airlift vine mush. — I'm not too good with food if it isn't what I'm used to. People laugh at me for drinking Tab, that's okay, at first I started doing it for an affectation, because it was a girl type drink.

Over and over again these affectations and not much sense of a real personality underneath them.

Well anyway—Philip's mom kept shaking her head with happiness watching me eat and I got a queer kind of loser feeling in my stomach. For I'm just this phony nut boy and you'd think she was serving the Duchess of Windsor. I wanted to be noticed, I think; to feel different somehow, so I did a lot of stupid things, I remember in graduate school all us grad students had these offices in the English Department and the other students put up posters in theirs, oh, these dull things, D H Lawrence or Virginia Woolf, and I had my posters of Farrah and Raquel Welch, and this one

guy comes into my office and says, "God, how jejune!" After dinner I remark on how dark it's getting outside. "Can I stay over?" I asked Philip, all bright-eyed and bushy-tailed, this phony garbage.

"Sure, if you want. It's no palace, but—sure."

Goldie Mandel dried her hands on her apron and joined in the fun of digging out the old cot from the basement storage room. The cot they used for when relatives came to visit. Must have been rats in it all summer though. No, this is no good. The three of us stared sadly at the discolored chewed cot like relatives at a funeral.

"You'll have to sleep in Phil's bed," she said. "Philly can sleep with me."

"I don't mind sharing," I said demurely. "Philip and I can sleep together."

"He goes downtown, they call him 'Philip.' Look at his angry face, you know, in my mind he's still my baby. I guess mothers will never learn. Sorry, Phil!"

Philip was dying a million agonies of chagrin. Any minute now she'd be hauling down the photo albums from the vulgar, *glassed-in* sideboard in her dining room. The photos of him crying at his circumcision they all found such knee-slappers. Or how about when he played Hamlet in PS 23 in Goldie's stockings taped tight to his ass with electrical tape, for tights? But finally, with many additional expressions of gratitude and wonder, his mother turned away, and retired to her part of the flat, I hope for good, even Yma Sumac retired, why can't she! "Goodnight, Philly, good night, Mr. Killian, thanks ever so for the mums."

"They're not mums," Phil said.

"Listen to Mr. Luther Burbank with his wide flower experience," I heard her snort in the darkness.

"Do you *have* wide flower experience?" I asked him, and when I saw him blush I knew he was thinking of me.

In bed he was careful to turn away as I stripped to the skin. "There's some extra pajamas," he ventured, "in the dresser."

"You sound like your mother," I replied. As I turned to examine his posters and souvenirs, I felt him gaze on my body, and casually enough I picked up my balls with both hands, as if to scratch around

them, and I tickled the smoother vein that kind of separates them, feeling the heat and throb, as the quiet stillness of the night pushed through the room, a deep lush quiet that was broken only by the ominous rumble of a motorbike down below. "Nice room," I said.

"It's not a nice room," he replied, in a low fervent voice. "How can you be so patronizing of me."

"Okay," I said. "It's not what you want. But it's okay."

"Why did you come here, don't you want to leave me any pride?"

"I want to be your friend," I said, ingenuous as a china doll. Naked I approached the bed and stood beside it, my elbows close in to my sides, my hands outstretched. "There's this gap between us I want to close over. That's why I came. Hey, this looks plenty big enough for two," I added, lifting myself by the cock into the bed. "Shove over, Philip, don't be a hog."

How old were you when this happened?

Oh real young, like twenty something, or yes. Philip was older than I, but to me he seemed like a boy to me. His long smooth body like a field of new snow, in his immaculate blue pajamas, striped with thin lines of black, buttoned up to the very top of the neck. "Aren't you warm in those?" I asked.

"Why are you here?" he kept asking me, just like an ignorant tourist or something. "You and all the rest of you treat me like dirt under your feet."

"I want to make it up to you," I told him, honestly. Then I lied, "You and me just got off on the wrong foot, that's all."

"What do you mean, wrong foot? What are you implying?" Like I wasn't supposed to know he was queer as Cole Porter.

"Listen!" I cried out. I shoved my pillow and face near to his, and lowered my lashes. Demure. Oh, I thought of this story about what I'm afraid of, I mean besides AIDS, and also being homeless and so forth. But Dodie and I went to lunch or something with Leslie Dick and Peter Wollen and for some reason, maybe a dog passed by, and he said he's afraid of large dogs, ever since he was a child in his native country, which I'm pretty sure is England. Then it turned out that Leslie is afraid of rats. I forget

why, it was something about she had a rat in her cradle or something. But anyway she was working at Cal Arts, and had to ispect the art projects of the students, and this one girl disliked her and she had to go into this girl's room, this big warehouse type dorm like a cave, and this girl had put all kinds of wood up to make a fort, and vegetation, I mean like barrels of rotting food in this awful warren of spores and—

And rats.

It was like this installation like Joseph fucking Beuys she was making, this awful girl. And this was at night, too. In what little light there was she wore this malicious grin—it was as though she somehow knew ahead of time that Leslie hated rats. Well anyway there I was and I was saying to Philip, "I—feel funny saying this, but —ever since we met I've been fighting this strange attraction, to you, Philip. . . . No, wait, don't get up, I just have to get this out of my system," and I told him of all the lonely nights I fought my strange attraction to him, and how I went to analysts for help, but how it was just too strong to deny any longer, and believe me, Phil was lapping this up. His eyes widened, narrowed, did every trick thing under the sun. His breath grew short, then he made himself hold still. "You'll think I'm crazy but hell, so do I, I just had to let you know, I don't know why."

"I don't know what to say," he brought forth finally.

"I know. I'm a pervert."

"No, it's not that. I understand."

"You do?"

His dark eyes closed and opened again. "I have some of the same—feelings, I guess," he told me. Gosh, scoop of the fucking century, but I put surprise and joy all over my face and gulped at him. Then I waited, then I whispered.

"You want to do anything? Philip? I'm right here." So saying, I reached out in the dark and put my hand to his smooth face, feeling the blush in his cheek, in the dark, unable to see his expression except for the fright in his tired, confused eyes. Something within me weakened my resolve, a variation on the feeling you get watching *60 Minutes* show Canadian trappers crushing minks in steel traps. "Relax now, this won't hurt a bit, and Philip? No one will know."

"Kevin," he said slowly, in little chunks, so I could barely make out

my own name. Under my hand his mouth moved, jittery, alive.

"Don't worry," I told him, as though he'd been in a terrible car crash and help was on its way. "No one will ever know. Kiss me," I said. "I want you to, it's okay."

His whole head was shaking on the embroidered pillowcase, as he faced me. I slid closer to his body, and waited until he got his breath. I continued to probe his face, his ear, his nose, his moving mouth that trembled but made no sound. In the night a succulent tenderness dislodged itself from my brain to take an eerie shape between us, like a third person we had both loved very much. But there was no such person, as far as I knew. Philip finally spoke. But only to say he couldn't breathe. "I used to have asthma," he said, downcast. "As a *child*. Maybe it's coming back."

"I don't think so. You're just surprised."

"No, seriously, I can't swallow." He pointed to his throat and his nose with the exaggerated fright of Harpo Marx, a dumbshow to convince me.

"I won't make you swallow," I promised, and I lowered my hand to find the hole in the front of his pajamas, and I found it, while Philip protested his asthma, in weak lost syllables. I clutched part of his dick in my hand, felt it warm and hard, its slick surface dry and smooth, like slate warmed in the sun. Gave him a squeeze, he liked it. He tried to say no, with his voice, and my finger slid down the length of his cock to his balls, poking them a bit as if to say, anyone home, and out of nowhere Philip stopped demurring and laughed a laugh of pure pleasure, his head thrown back and his mouth open to the big world.

"I can't believe this!" he shouted.

"Quiet, now, you'll wake your mother."

"I can't fucking believe this," Philip yelled, a little less loudly. He seized my head and made me face him, and face to face we cracked up, in the blackness of the night his face was alight with joy. In a minute I had him naked and adoring below me as I pressed his shoulders down with my weight, his mouth smiling into the mattress, I tugged on his ears and brought his neck and head up high, riding his back like a jockey, his thin strong waist my

saddle. "Now you'll get that wide flower experience." His pajamas lay crumpled on the rug like a blue and black candy wrapper after a fair.

And then careful to face him, I lowered myself onto Philip's face, felt him suck all the rich juices out, while his hands crept up along my legs like cunning cloths. I saw the whites of his eyes gleam in the dark, his head thrown back in excitement, his lips wrapped around the shaft of my cock. I guess I was trying to give him something back.... He swallowed me up, I felt the walls of the room come in close for a minute like anxious spectators—; then they retreated to their proper place, made corners again, yanking the books and furniture back to themselves, realigned.

In the morning when I awoke he was awake already. Biting his nails and so forth. He was very nervous. I wasn't really thinking about him that much, no, just more about my friend and what next. You know, we were kids. Thom Gunn told me—you know I'm writing this book with Lew, this book about Jack Spicer's life—anyway Duncan and Spicer and all these gay Berkeley guys were living in this one house, and somehow so was Philip K. Dick. And Thom Gunn once asked Duncan what it was like to be a roommate of Philip K. Dick. And one night Duncan thought he was all alone, reading and writing in his room, and he looked up and there in the open doorway Philip K. Dick is just standing there you know, jerking off, or getting ready to come. And he made this one, you know, motion of his hips, like Nijinsky in the *Spectre of the Rose*, and came onto the floor, and Duncan was too astonished to say a word. And Philip K. Dick just turned around and went back to his room and they never talked about it, or nothing.

But why did he do that?

I don't know—Duncan said, years later, that it was just the pressure cooker atmosphere, this steam heat . . .

So Philip was biting his nails—my Philip, nervous, you know. "Everything's going good," I said, stroking the soft length of his prick. Skittish at first, Philip began smiling halfway through, like a kid at the circus. In daylight his skin shone as though the sun was trapped into it. "Yeah everything's working," I said. "But the thing is, I have this friend and I was wondering, could he come over sometime—he's real

nice." Now here's where I want you to be my powerful friend.
Okay.

At his look instantly I realized I'd outsmarted myself. In a violent motion, as if stung by bees, Philip slid his hips further down the mattress. "What *friend?*"

"Just this guy."

"What his name?"

"He's sharp, real sharp."

"Real sharp, eh? Name wouldn't happen to be George Dorset, would it, Kevin?"

"Yeah, so what about it? Do you want to?"

"Is that why you came here? To be his pimp?"

Philip vaulted up out of bed, pulled the bedspread round his waist. He wouldn't look at me. "The fabulous George Dorset who gets under everyone's skin like *cocaine!*"

I wondered if his mother had knitted the spread, large splashy patches of green, blue, orange and zebra, like a Mondrian crossed with a traffic signal. "Your mother knit that quilt, Phil?"

Furiously he struggled into a pair of pants, under the blanket, with the usual success.

"Is she *Amish?*" I persisted. "They do wonderful work down in Pennsylvania Dutch country."

"What's the matter?" I said. "I'll pay you, American money."

"What do you think is the *matter,*" said Philip. His whole bearing stiff, his shoulderblades pointed and flaring, he stood at the opposite side of the room by his open closet door. Inside the closet, hanging from a bare horizontal pole, hung his familiar blue suit with the shiny patches at the knee.

I leaned back against the pillow. It was then that a wild desperate knocking thundered and rattled through the house. I must have jumped a foot. "Jesus Christ, what's that?"

"My mother—that's her broom."

"You boys up? Want some French toast or Cheerios?"

"What's the matter? You gave me a big present, then you took it all away, that's the *matter, Kevin.* —No, Ma!"

"What's that?"

"Oh, fuck it."

"I'm not used to being treated like this." I arose from the bed and, made an invisible camera with my hands and thumbs, held it to my eyes, and pressed the invisible shutter. Phil flinched and held the blanket tighter, cowering by his closet door. I took the blanket and whipped it off his waist, and brought my mouth close to his ear so I could whisper, "You're *still* hard, Philly boy. Don't act like I raped you because we both know different. Look at it, wriggling like an animal. Don't hide it with your hands, look for a change!"

"I'm not just waltzing into your life and slumming, if you think so, you're all wet!"

"I suppose we had this date from the beginning," Phil said. "Don't get me wrong, I like American money."

He was weakening, well, who wouldn't? I didn't hold it against him. My hand tightened around his balls, pleasurably, so he couldn't help but gasp a little, in a goony way that recalled the heroines of my favorite romance comic books. I traced the line of his lips with one finger, hushing him. Then I traced a circle around his nipple, my arm over his shoulder, and circled again, tighter and closer, feeling him relax against my hip, backing into me weakly, as though overpowered by a super-serum or chloroform. I pinched the nipple between two knuckles and bit the side of his taut neck, till he caved in completely, fallen apart, his hard-on a tool for operating like the gearshift of a car I could swerve in and out of first and second. "My boy," I said to him.

So I got on the phone. "George? This is Kevin. Guess where I am."

I don't know where you are, how should I know, am I supposed to be like Kreskin to you, where are you, at home?

"No, I'm at the Mandel residence. Philip's here too. His mother's out at the market."

And where is Philip, tell me Kevin.

"Phil? He's down on the floor, sucking my cock. Want to watch?"

Uh-huh, uh-huh.

"My big hairy red hard dick."

Yes, Kevin, yes, Kevin.

"Want to watch?"